Capturing
RADIANT COLOR
In Oils

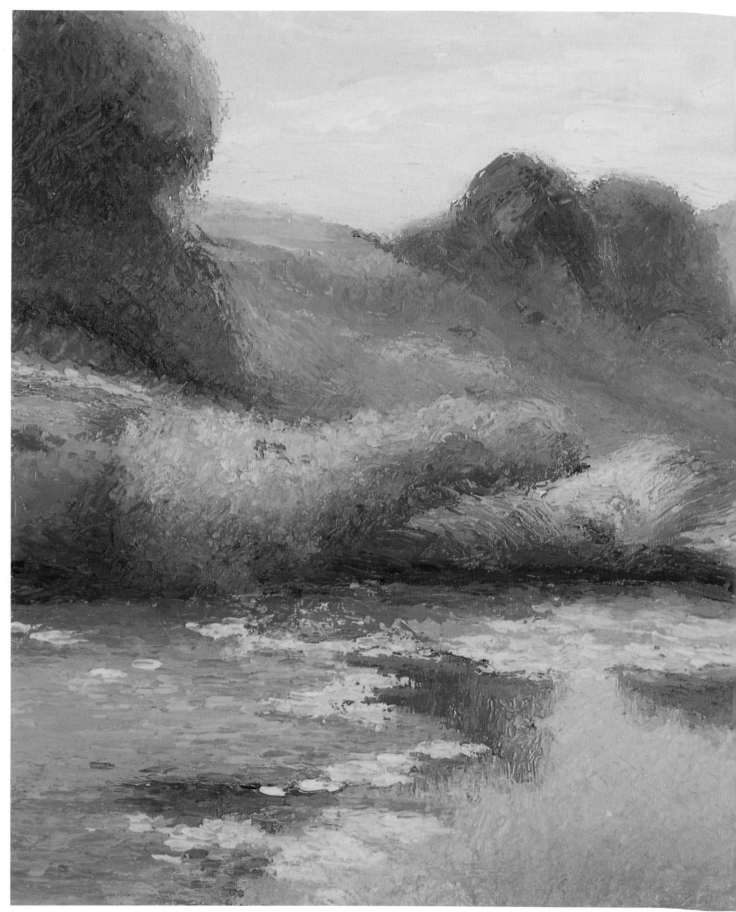

Autumn Pond, Susan Sarback, 12″ × 16″

Capturing
RADIANT
COLOR
In Oils

SUSAN SARBACK

with Paula Jones
(WRITING COLLABORATOR)

NORTH LIGHT BOOKS
CINCINNATI, OHIO

ABOUT THE AUTHOR

Susan Sarback grew up in New York City, where she was influenced by great art from an early age. Her formal training began at the High School of Art and Design. She then studied at the Hartford Art School (University of Hartford), The Academy of Art College in San Francisco, Cornell University and the Cape School of Art with Henry Hensche in Massachusetts. She holds both a bachelor's and master's degree in art.

She received a scholarship to the Academy of Art College in San Francisco, has won several juried exhibitions and is listed in *Outstanding Young Women of America 1991*, the *Encyclopedia of Living Artists*, *Who's Who in American Women* and Oxford's *Who's Who*.

Her work has been exhibited in galleries throughout the U.S., including New York City, San Francisco, Seattle, Santa Fe and San Diego. She is currently represented by the Lawson Gallery, Seattle; Studio B Gallery, Burlingame, California; and the Wohlfarth Gallery, Washington D.C. and Provincetown, Massachusetts.

Sarback has presented slide shows and lectures about light and color to art schools, universities, art associations, societies and clubs throughout the U.S., and she has taught painting workshops all along the West Coast since 1986. She currently resides near Sacramento, California, where she founded the School of Light and Color and teaches small workshops throughout the year to artists from around the world. (For more information, contact the School of Light and Color, P.O. Box 1497, Fair Oaks, California 95628.

Capturing Radiant Color in Oils. Copyright © 1994 by Susan Sarback. Manufactured in China. All rights reserved. No part of this book may be reproduced in any form or by any electronic or mechanical means including information storage and retrieval systems without permission in writing from the publisher, except by a reviewer, who may quote brief passages in a review. Published by North Light Books, an imprint of F&W Publications, Inc., 1507 Dana Avenue, Cincinnati, Ohio 45207. 1-800-289-0963. First paperback edition 2000.

04 03 02 01 00 5 4 3 2 1

Library of Congress has catalogued hard copy edition as follows:

Sarback, Susan
 Capturing radiant color in oils / by Susan Sarback, with Paula Jones.—1st ed.
 p. cm.
 Includes index.
 ISBN 0-89134-578-7 (hardcover)
 1. Color in art. 2. Shades and shadows. 3. Painting—Technique. I. Jones, Paula. II. Title.
ND1488.S27 1994
752—dc20 94-3163
 CIP
 ISBN 1-58180-061-4 (pbk: alk. paper)

Edited by Rachel Wolf
Designed by Sandy Conopeotis

The permissions on page 132 constitute an extension of this copyright page.

METRIC CONVERSION CHART		
TO CONVERT	TO	MULTIPLY BY
Inches	Centimeters	2.54
Centimeters	Inches	0.4
Feet	Centimeters	30.5
Centimeters	Feet	0.03
Yards	Meters	0.9
Meters	Yards	1.1
Sq. Inches	Sq. Centimeters	6.45
Sq. Centimeters	Sq. Inches	0.16
Sq. Feet	Sq. Meters	0.09
Sq. Meters	Sq. Feet	10.8
Sq. Yards	Sq. Meters	0.8
Sq. Meters	Sq. Yards	1.2
Pounds	Kilograms	0.45
Kilograms	Pounds	2.2
Ounces	Grams	28.4
Grams	Ounces	0.04

DEDICATION

This book is dedicated to all those who have devoted their lives to the search for beauty, truth and love through the arts.

With special dedication to my family — Arthur, Blanche, Arlyne and Michael — for their loving support and encouragement throughout the years.

ACKNOWLEDGMENTS

I would like to thank the following people:

My writing collaborator, Paula Jones, for her extensive efforts in helping to clarify, organize and find words for all the information in this book. She lent valuable insight as the material evolved and made the text clear and easy to follow.

All the painters who contributed paintings for this book: Dale Axelrod, Lee A. Boynton, Roberta Anne Bullinger, Chuck Ceraso, Stephen Craighead, John Ebersberger, Cedric Egeli, Ingrid Egeli, Joanette Egeli, Frank Gannon, Peter Guest, Paula Jones, Dezie Lerner, M. Manegold-Wanner, Ken Massey, Margaret E. McWethy, Hilda Neily, Stephen Perkins, Ernest Principato and Camille Przewodek. Their paintings show a range of expression wider than any one person's work could convey.

Mark Alexander, for his substantial efforts in the early stages of the manuscript. His efforts were key in formatting the basic outline and creating an initial draft.

My photographer, Don Bentz, for his enthusiasm and expertise.

Mary Carroll-Moore, for her editing expertise and encouragement.

My editors at North Light Books, Rachel Wolf and Anne Hevener, for their help and interest.

Henry Hensche, for teaching me how to finally see light and color. His way of seeing and painting changed my life.

All my students who encouraged me to write this book.

Bob and Jan Ahders, for providing many scenes and subjects to paint.

David DeLapp and Kathryn Griffen, for their continued support and encouragement.

My family — Arthur, Blanche and Arlyne — for the years of encouragement, support and love that enabled me to devote myself to art and eventually to write this book.

My husband, Michael, for his patience, love and support through the years I worked on this book.

INTRODUCTION

1

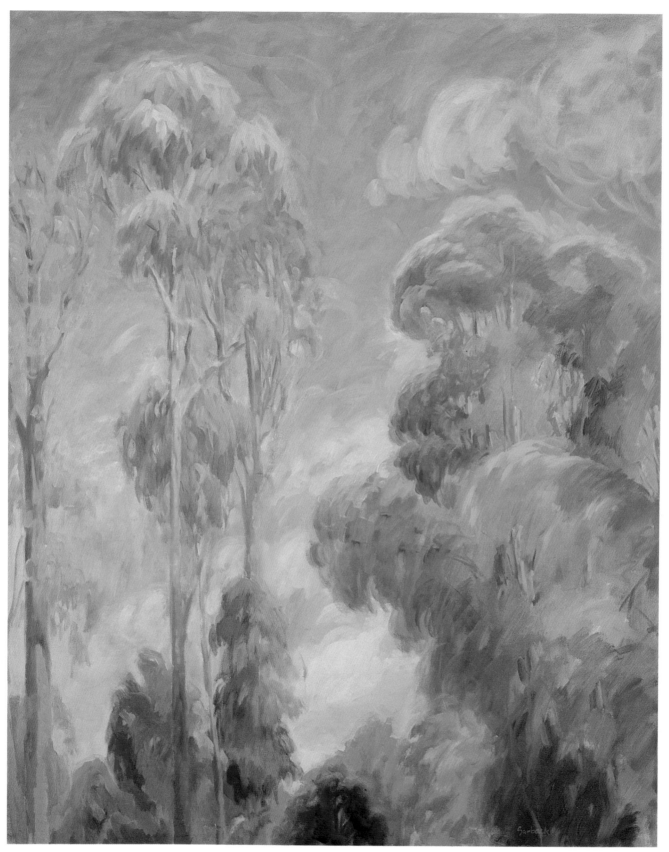

Treetops, Susan Sarback, 23″ × 18″

INTRODUCTION

This is a book about seeing and painting color—the radiant color inherent in light. It is a guide to help you deepen your understanding of light and color, expand your own color perception and bring this new awareness into your painting. *Full-color seeing* is the name I have given to a specific method for seeing and painting color as affected by the surrounding light. Full-color seeing can add an exciting richness to your vision and a radiant quality to your art.

This book is an opportunity for you to learn a new language of light and color, a language based on direct visual perception. The initial chapter gives an overview of different ways of seeing and painting color. Then, I explain two vital keys to full-color seeing—receptivity and relaxation—and several important vision exercises. The following chapters give step-by-step instructions on painting using full-color seeing and describe in detail the third key to full-color seeing—seeing color relationships. The final chapters discuss atmospheric conditions and advanced subjects, presenting a range of work by a variety of painters who use radiant color.

The artistic journey that led me to full-color seeing began when I was fifteen, attending an art high school in New York City. I spent hours combing art galleries and museums, absorbing all the great works the city had to offer. Of everything I saw—all the great painters of many different periods—I returned most often to the Monet room at the Museum of Modern Art. The huge expanse of water lilies captivated me.

For eight years, art schools led me down a conventional path. I studied all the traditional subjects: anatomy, design, drawing, composition, perspective and color theory. I studied local color, expressive color, imaginary color and symbolic color. All of this fueled my desire to be an artist, but I felt something was missing. Where was the sense of freedom and light I had loved in Monet's work? Even my best paintings didn't come close to capturing this radiance.

Several years after art school, a friend told me about a master painter, Henry Hensche, who taught specifically about light and color. When he gave a workshop near my home in California, I decided to attend. Hensche taught his students how to actually see the way light affects color. His approach to color did not rely on theory or rules, but on keen perception. He taught how to see color based on color relationships and the overall atmosphere of light. It was the missing link I had been searching for.

Driving to his class every morning, I began to notice how the landscape around me looked different. My vision was changing. Common everyday scenes were transformed; buildings, trees, cars, even shadows on the road revealed radiant color. Everything was alive, pulsing with light and color. I loved this new way of seeing and was determined to learn more.

I studied with Hensche in the following years until his death in 1992. I spent many summers at his school, the Cape School of Art in Cape Cod, Massachusetts. The Cape School was founded in 1899 by Charles Hawthorne, Hensche's teacher and a contemporary of Claude Monet. Hawthorne was interested in devising a teaching method for painters to learn to see and paint with the vision of the Impressionists. At the Cape School, I learned a new way of seeing and painting that gave me insight into how to paint with the radiance I had seen in Monet's paintings.

Many of Hensche's students have gone on to become successful artists, continuing to develop and apply, each in his or her own way, the basic principles he taught. This book contains paintings by several of Hensche's former students from all over the country.

From the beginning of my studies, I knew that I wanted to share what I was learning. For many years, I kept notebooks about art and took notes all through my classes with Hensche. Over the years, through teaching and painting, I learned more and more. Several years ago, I founded the School of Light and Color in Fair Oaks, California, where I give regular workshops and classes. Eventually, I decided to write a book. I asked a writer friend, Paula Jones, who had also studied painting with Hensche and later with me, to help organize and focus the information and to help find the words to express it clearly.

This book contains the fruits of many years of learning, teaching and painting using the methods of full-color seeing. It's based on what I learned with Hensche, and it also reflects my own personal insights and point of view. Full-color seeing and painting has been of the utmost value to me in my growth as a painter: It finally filled a longstanding gap in my understanding and perception of light and color. My hope is that it may provide just the right stepping-stone for you on your journey as an artist.

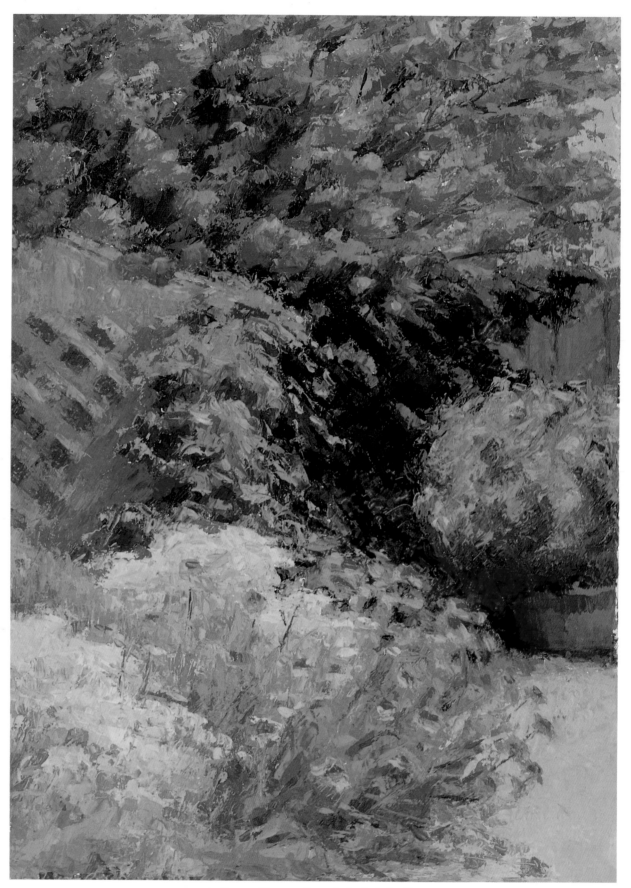

Summer Blossoms, Susan Sarback, 14″ × 9″

SEEING AND PAINTING COLOR

The eye is the jewel of the body.

HENRY DAVID THOREAU

The eye, that most wonderful of human organs,
is infinitely perfectible, and it can attain,
when intelligently trained, a marvelous acuity.

GUY DE MAUPASSANT

The artist's eye, grafted on his heart,
reads deeply into the bosom of nature.
That is why the artist has only
to trust his eyes.

AUGUSTE RODIN

The real painter humbles himself
and looks at everything with a fresh eye.
For him every painting is a journey of discovery.

HENRY HENSCHE

I would like to paint the way a bird sings.

CLAUDE MONET

E ver since childhood, I've loved making pictures. I was always looking for a way to express myself through drawing and painting. As I got older, I attended many art schools and experimented with many different approaches to painting. Eventually, I discovered my passion as a painter rested with light and color. Creating radiant color in a painting fascinated and inspired me most.

In my early studies, I learned to evoke a sense of light using value differences — placing light and dark areas next to each other to produce an effect of light. My paintings resembled life, but they weren't capturing the radiance I wanted. I began to suspect that the key to more light and life in my paintings lay in the choices of the actual colors, or hues, themselves, and not just in their values.

These paintings represent examples of seven different approaches to painting light and color. I chose a simple, ordinary scene so that the subject matter would not distract from showing the various ways of using color. You may find it useful to take a single mass and trace its color through the seven paintings. For example, the shadow on the house moves from gray, to neutral, to a bold green and, finally, to a luminous blue in the final example, full-color seeing.

Local Color

Expressive Color

Color Theory

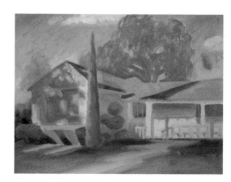
Personal Color

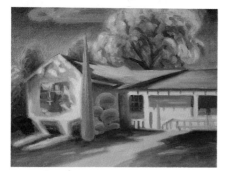
Imaginary Color

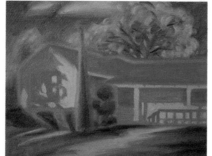
Symbolic Color

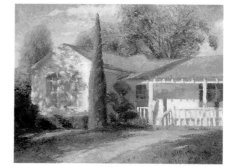
Full-Color Seeing

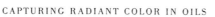

SEVEN APPROACHES TO COLOR

I studied many approaches to color and thought of them as a variety of languages. The following is an overview of the seven basic ways of seeing and painting color that I studied: local color, expressive color, color theory, personal color, color from memory or imagination, symbolic color and full-color seeing. These seven categories describe the ways artists have used color throughout history, either singly, or more often, in combination. This discussion is not meant as a comprehensive survey, but rather as a background for understanding full-color seeing, the key that finally unlocked the mystery of light and color for me. Not based on a particular style or subject matter, it is a way of seeing and painting color that can be carried into any style, medium or subject matter.

Local Color

Red is the local color of apples; yellow, the local color of lemons; blue, the local color of the sky on a clear summer day. *Local color* is the color of an object independent of such considerations as the light in which it is viewed or its relation to all the other colors in the field of vision. Thus, grass is green, tree trunks are gray or brown, and the shadow of a tree trunk on grass is simply a darker green. This is how we are often taught as children to see color.

Many of the world's masterpieces have been painted using primarily local color, from the works of the seventeenth-century painter Vermeer and the nineteenth-century painter Corot to the work of contemporary photorealists.

Local color is an excellent tool for description. It allows us to easily recognize images in representational art; an amorphous green shape atop a brown stick immediately becomes a tree. This ability to create likenesses is one of the pleasures of representational art, and local color can serve this purpose well but at a cost. For example, if I paint a roundish shape in shades of yellow, you may recognize it as a lemon. Suppose, however, that I am painting outdoors on a late summer afternoon. Painting only in shades of yellow ignores the setting sun's casting a deep pink light on one side of the lemon, the still blue sky overhead casting a coolish tint from above, and the greenish light bouncing up from the emerald dropcloth. Focusing solely on local color can lead to a kind of visual shorthand in which images are aptly conveyed, but richness and subtlety are lost.

In all the years I painted in local color, I learned only about value, not color. Painting with values is called *tonal painting*. One teacher told me, "You can use any color as long as you get the value correct." Thus, local color became an extension of drawing, using values (lights and darks) to represent the effect of light. I realized I wasn't really learning to *see* color. I knew there must be something more.

Local Color, 11″ × 14″

This painting uses primarily local color, the color of our everyday vision. The grass, trees and bushes are a variety of greens; the house is white with gray shadows; and the sky is simply blue with white clouds.

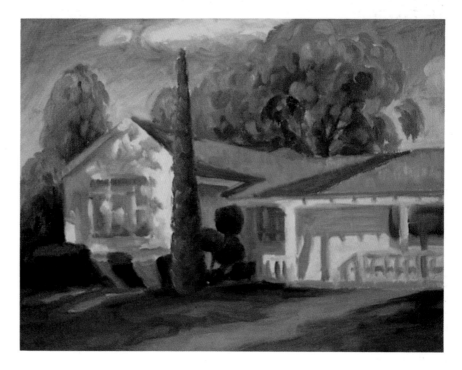

Expressive Color

My next study dealt with *expressive color* — color based on feeling. This way of painting frees color from the description of natural appearances and allows the artist to respond directly from his deepest feelings and emotions. It relies on intuitive, spontaneous feeling. Van Gogh, with his passionate enthusiasm and love for life, used expressive color to convey his response to his subjects.

Rather than seeing brown hair, the artist might intuit it blue or violet. Instead of observing the color differences between one side of a face and the other, the artist may sense one side pink, the other greenish. To feel color in this way gives the artist a freedom of expression and a release from observable reality. Color is used as a powerful means of expressing and evoking emotions.

Using primarily expressive color in my paintings was a moving experience for me. I could express my deepest feelings about my subjects. For several years, I made abstract paintings with large, flowing forms using expressive color, but after a while I noticed I was only repeating certain color combinations. My sense of exploration and fulfillment eventually diminished. I still wanted my paintings to capture the radiance and glow of light, yet using my feelings to guide my color choices did not really lead in this direction. So I began looking for ways to paint with a more precise knowledge of color.

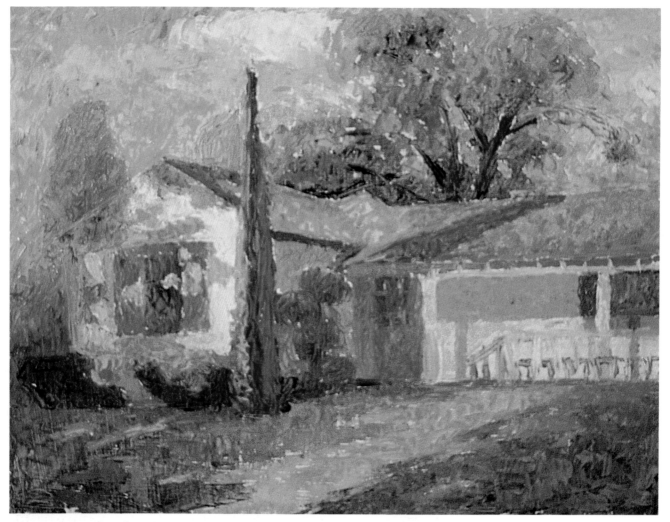

Expressive Color, 11″ × 14″

A feeling of exuberance is expressed in the bold, direct colors of this painting. The colors were chosen to create an impact of energy and vitality. This type of painting can be very colorful without holding to visual observations.

Color Theory

Rather than paint color based on seeing or feeling, some artists pursue a thinking approach. Theoretical color relies on scientific color analysis or on general rules for commonly observed experiences. For example, many color theorists would point out (as did Leonardo da Vinci) that cooler colors (blues and purples) recede, and warmer colors (reds, oranges, yellows) come forward; or they might provide a formula for achieving the correct color of a shadow. Artists using these approaches often employ these theories to create desired effects in their paintings.

Some renowned color theorists working around the turn of the century were Itten, Birren and Chevruel, whose findings influenced the French Impressionists and the Pointillists. The Pointillists Signac and Seurat based their technique of painting in distinct dots and dashes of pure complementary colors on the theory that the colors blend in the eye of the viewer.

By the mid-1950s, Josef Albers had experimentally demonstrated that color is relative. Through analytical studies of color pigments, Albers showed that colors are not perceived in isolation. His aim was to show how color pigments interact with each other and reveal the effects colors have on each other.

By placing identical squares of a specific color within larger fields of varying colors, Albers demonstrated how the surrounding field influences our perception. A small, green square seen against a red background will appear greener than the same square seen against a blue background. Albers's studies formed the basis of his paintings and those of many artists to follow.

For me, the challenge of color theories is in relating them to my own perceptions. I studied Albers's *The Interaction of Color* and came away with an increased understanding of color pigments and color relationships, but I didn't know how to apply this understanding to my own vision. I could relate color pigments and manipulate them to produce certain results on the canvas, but I hadn't learned to see my subjects any better.

In fact, none of the theoretical approaches I studied addressed how to actually see color. Although some of the theories I learned sensitized my eyes to color relationships, I was not satisfied to paint mainly from a theoretical approach.

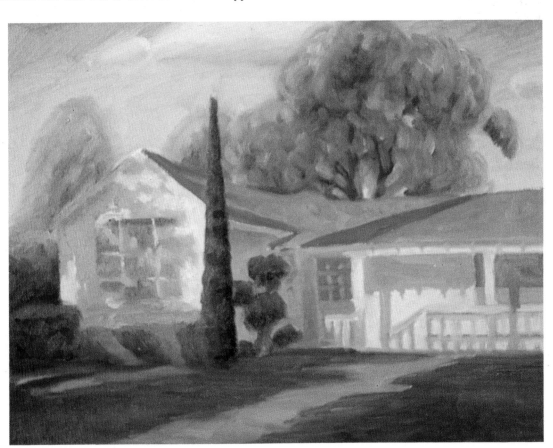

Color Theory,
11″ × 14″
I used two theories to help determine the color choices in this painting. First is the rule that cool colors recede and warm colors come forward. Second is a formula for cast shadows using the color of the object, its complement, and the color on which the shadow is falling. Notice the background trees are cooler, the foreground shadows are warmer, and the cast shadow on the house is an indescribable neutral tone.

Personal Color

Personal color is a term I use to refer to purely individual color choices, from color harmonies that the artist finds pleasing to seemingly arbitrary, random colors. It became popular in painting during the middle of the century as artists experimented in moving beyond their predecessors. Abstract artists like Jackson Pollock and Helen Frankenthaler displayed less interest in color theory and descriptive color than in abstract problems disassociated from objective reality. They used color abstractly, without necessarily any external or emotional reference. These artists are like those who feel color, but personal color is less emotionally or mentally derived; it is simply based on the personal choice of the artist.

As in my experiences with expressive color, I eventually found myself repeating my own color preferences in my personal color paintings. Once again, restlessness gradually replaced my initial sense of freedom and excitement.

Personal Color, 11″ × 14″
This painting is based on a range of colors — blues, purples, reds and oranges — selected to create an unusual effect. The intention is not to describe nature or create an emotional impact. Personal color can be rather arbitrary, as in this case, or can tend more toward decorative and pleasing effects.

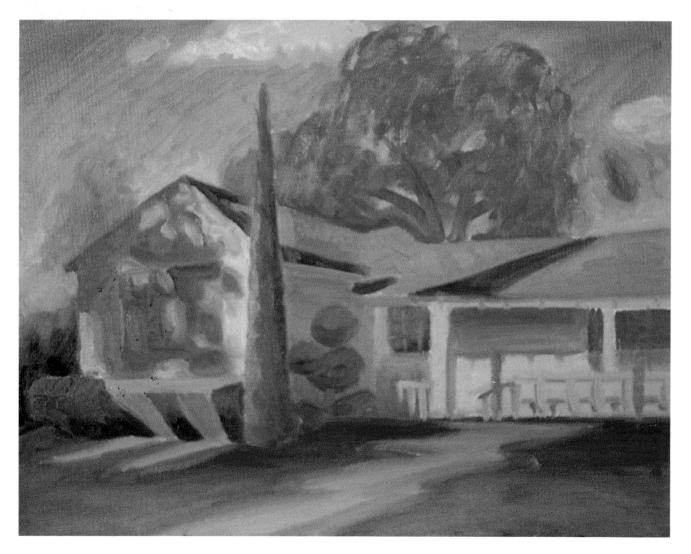

Color From Memory or Imagination

Many painters throughout history have painted from either memory or imagination. Some make quick sketches or begin paintings outdoors, then rely on memory to complete the painting indoors. Others, like Marc Chagall, combine elements in a way not seen in this world and paint imaginary scenes. Still others, like surrealists Salvador Dali and Rene Magritte with mystical paintings and illustrations, work from an inner vision they bring to life on canvas.

Memory and imagination both involve the creation of a mental image that can then be used as a source for painting. I discovered that the mental images I was able to create were too generalized to serve me well. They did not capture what most interested me, the exact quality of light at a specific time and place. Leonardo da Vinci spoke of this limitation when he said:

> Whosoever flatters himself that he can retain in his memory all the effects of nature is deceived, for our memory is not so capacious; therefore consult nature.

After prolonged study, however, the memory begins to retain more and more information. Monet, through years of continued observation from nature, had so developed his visual memory of light and color that he was able to successfully complete paintings that he had begun outdoors in his studio.

Imaginary Color, 11″ × 14″

The colors in this painting were chosen to create a world apart from observable reality. For example, orange clouds in a green sky with blue land and an orange bush glowing in the shadows could exist only in the imagination of the artist.

Symbolic Color

Colors often carry symbolic meanings within a given culture. In Western culture, black is a sign of mourning, where in some Asian cultures, other colors, such as purple or cream, are worn for mourning. Artists can make use of these symbolic meanings in their work. Many religious, allegorical and traditional art forms rely on symbolic colors to help convey their message.

I discovered symbolic color in my search, but my interests leaned toward light and perception, and away from conceptual meanings associated with specific colors.

Symbolic Color, 11″ × 14″

The colors in this painting have been chosen for their symbolic value. The red house stands for the security and warmth of hearth and home. The surrounding dark grays represent the stormy challenges of life. This is just one example of how this scene could be painted using symbolic colors to make a statement.

Full-Color Seeing

After I graduated from art school, I continued to attend workshops, classes and seminars. I often asked my teachers how to paint the color of a cast shadow. One teacher said that a shadow may be blue but is usually a neutral color, such as gray. Another suggested a formula: Take the color of the object casting the shadow, mix it with its complement, and blend this mixture with the ground color on which the shadow falls. Still another told me to simply make the shadow color a deeper value of the ground color.

Finally, I found a teacher, Henry Hensche, who taught me how to see the way light affects color. He showed me that artists can learn to simply *see* the color of a shadow. Sometimes a shadow is blue, sometimes violet, red, green or a complex hue impossible to describe in words. It could be any color. Color is based not only on the local color of the object, but on all the colors surrounding it, the way the light is hitting it, the time of day, the season, the atmospheric conditions, the viewer's distance from the object — too many factors for a formula to incorporate.

Hensche developed a method of teaching how to see the way light affects color. This way of seeing color is based on direct observation from life rather than on imagination, theory or memory. It relies solely on vision. I call this expanded color vision full-color seeing, because it is a way of seeing the full range of color. This vision was the key to the light and radiance I had been looking for.

The Impressionists, especially Claude Monet, saw the way light affected color — the way an object appeared to be different colors at different times of the day and under varying weather and seasonal conditions. Monet's series of

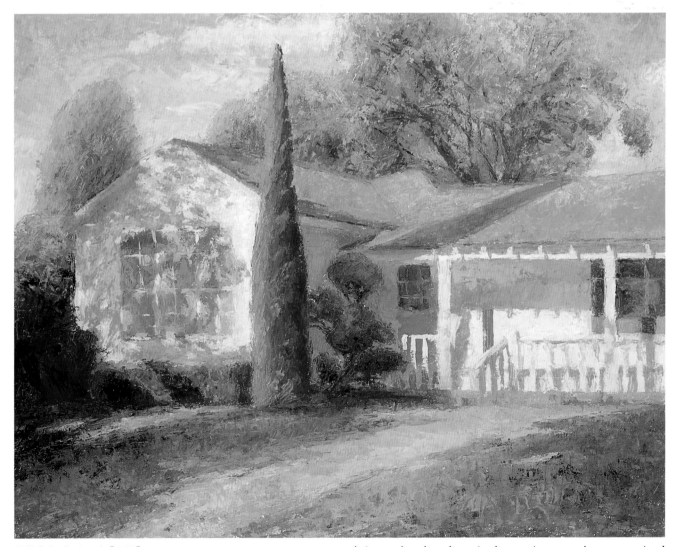

Full-Color Seeing, 16″ × 20″
This was painted on a sunny, slightly hazy morning, with careful observation of how the pervading light affected each color. The color choices are based purely on visual perception, not on theory or emotional expression. Compare the colors of some of the masses with the other paintings. Notice the sense of radiance and light this approach imparts.

haystack paintings supremely embodies this understanding. The local color of a haystack is the color of straw, yet Monet saw and painted them using the entire spectrum of light, from reds and oranges to greens, blues and violets.

Full-color seeing is the vision of Impressionism. The Impressionists were more interested in light and atmosphere than in form. Yet to *see* with this vision does not mean one has to *paint* in the style of the Impressionists. Full-color seeing can be applied to well-defined, carefully rendered forms as well as to loose, flowing, soft forms.

HOW WE SEE

Since full-color seeing is based on visual perception, I want to briefly talk about how we see. Learning full-color seeing is learning a new vision. What is the main factor that determines how and what we see?

Our eyes are extremely sensitive, yet our vision is notoriously inconsistent. Experiments show that a person sitting in a totally dark room can register the impact of a single photon of light on the retina, yet crime studies reveal that eyewitnesses are, in fact, highly unreliable and often contradict each other. What causes this?

In *Help Yourself to Better Sight* (Prentice-Hall, 1949), Margaret Darst Corbett, an expert in the field of visual training, explains:

> We see, hear, taste and smell with the mind. If you attempt to study, your attention elsewhere, you learn nothing of your subject. If you pass through a rose garden, your mind intent on things beyond, you fail to catch the perfume of the blossoms. . . . The sense organs are merely aids to their respective brain centers; it is the mind which perceives. If the mind is tense and strains or is temporarily absent, the senses cannot function.

One way the mind determines what we see is by filtering out information we perceive as unnecessary. We gradually become accustomed to a stimulus and then begin to tune it out as it loses its immediate relevance or newness. For example, if someone in the next room turns on a radio while you are reading, at first you may be distracted, but eventually the sound of the radio blends in with the other ambient sounds, and you are able to continue reading undisturbed.

This is a valuable mental process that occurs automati-

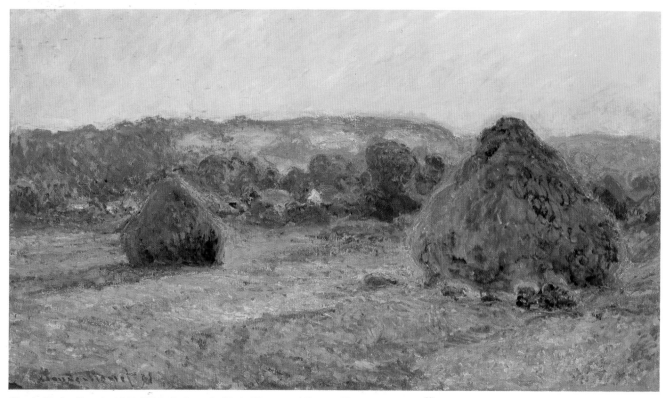

Claude Monet, French, 1840-1926, *Grainstacks (End of Summer)*, oil on canvas, 1891, 60×100 cm, Arthur M. Wood in memory of Pauline Palmer Wood, 1985.1103, photograph © 1993, The Art Institute of Chicago. All Rights Reserved.

Monet was a master at seeing and painting light, color and atmosphere. Through studying nature and refining his vision, he was able to transform these ordinary haystacks into a luminous painting of light and color.

cally many times daily, but it can work against us as we paint. Light surrounds us every day. With the exception of special effects, such as a beautiful sunset or the sky before a storm, we usually overlook the particular quality of light at any given moment. By learning to see with an increased awareness, we catch the subtleties of light and color that normally are lost to us.

SEEING BEAUTY

Learning to see the full range of color deepens our appreciation for the beauty in the world around us. A woman wrote to me about how she was still benefiting from one class she had taken more than two years before, even though she had not painted since:

I am very much aware of the infinite and constantly changing colors in my environment. Grays and browns don't exist. They have become subtleties of other colors. The bark on a eucalyptus tree can stop me in my tracks to take in its beauty. A day-long drive into the desert . . . is awesome as the light changes everything all the time. Rocks while camping are delicate purples, greens, blues and pinks. . . . My universe is now a constantly changing palette of colors. . . . This way of seeing changed my life.

I have seen full-color seeing and painting add meaning and value to my life and to the lives of many others. In the next chapters, I will present the foundations of full-color seeing, beginning with how to see and then moving into actual painting techniques.

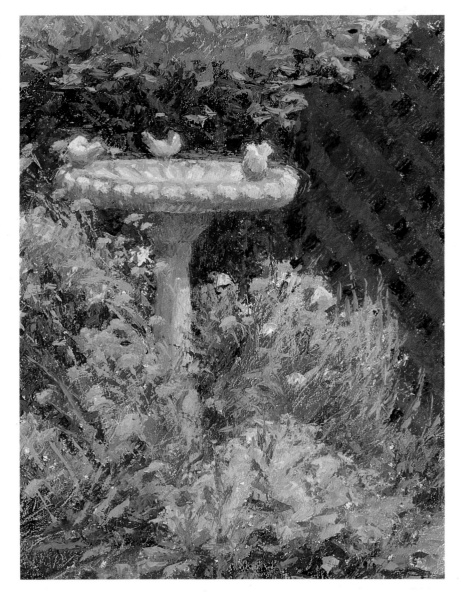

Bird Bath #1, Susan Sarback, 24″ × 20″ collection of Barbara and Charles Otto
The charm and warmth of a garden in summer are reflected in this painting. It was painted in late morning on a hot July day. With full-color seeing, a simple birdbath and flowers capture the radiant beauty of light.

Radiant Moment, Susan Sarback, 24″×20″

CHAPTER TWO

HOW TO SEE FULL COLOR

I want to be right not in theory but in nature. . . .
To achieve progress nature alone counts,
and the eye is trained through contact with her.

PAUL CÉZANNE

The richness I achieve comes from nature. . . . Perhaps my originality
boils down to being a hypersensitive receptor.

CLAUDE MONET

Anything under the sun is beautiful if you have the vision—
it is the seeing of the thing that makes it so.

CHARLES HAWTHORNE

There is nothing more difficult for a truly creative painter than to
paint a rose, because before he can do so he has first to
forget all the roses that were ever painted.

HENRI MATISSE

[W]ithout seeking to do so, one discovers newness,
and this is much better. Preconceived theories are the
misfortune of painting and painters.

CLAUDE MONET

I don't know a better definition of an artist than
one who is eternally curious.

CHARLES HAWTHORNE

I once saw a film of Claude Monet painting. He stood before his easel, painting outdoors in his garden. He looked out at the flowers, mixed a color on his big palette and applied it to his canvas. At first I saw nothing unusual, but after a moment it struck me—Monet was utterly relaxed. His hands were loose and flowing as they moved from palette to painting. His head nodded in a barely perceptible rhythm. All the muscles of his face were relaxed. Even his eyes and lips looked limp. He imparted a feeling of ease and fluidity, like a calm, peaceful river.

Relaxation and the open, receptive state it fosters are keys to full-color seeing. While instructing a young painter, Claude Monet explained: "But I don't teach painting. I just do it . . . there has been and will be only one teacher . . . that, out there." And he showed him the sky. "Go and consult it, and listen well to what it tells you."

The Irises, Susan Sarback, 11″×14″
This is a spring afternoon painting, done on days when the light was strong and bright, with the irises and bushes all in shadow. As I painted, I stayed loose, relaxed and at ease. This helps me to see beyond the local color. Notice especially the deep magentas and purples in the background bush's shadow areas, and the yellows and oranges of the grass in sun.

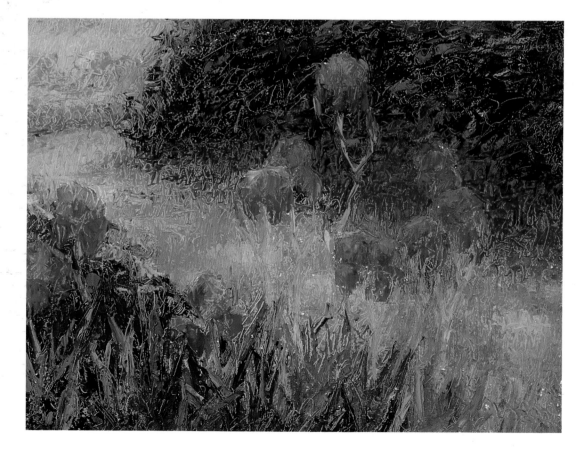

RELAXATION AND ALERTNESS

During the 1988 Summer Olympic Games, a runner who had won a gold medal was asked what was most important to his success as a runner; what he concentrated on most while running. "Being relaxed," he answered.

I can see color beyond my everyday vision only when I am relaxed. I have to be relaxed and alert at the same time and look for what the light can show me. This combination of ease and activity enables me to be receptive and sensitive.

The writer Aldous Huxley stated this principle clearly in his book *The Art of Seeing* (Berkeley, 1982): "The secret of efficiency is an ability to combine two seemingly incompatible states—a state of maximum activity and a state of maximum relaxation."

Huxley wrote his book because of success he had im-

proving vision without the use of corrective lenses by following exercises devised by Dr. William H. Bates, the author of *Perfect Sight Without Glasses*. Huxley distinguishes two kinds of relaxation: passive and dynamic. Passive relaxation is a state of complete rest, to rest muscular and psychological tensions. Dynamic relaxation, on the other hand, is active rather than passive. It is a state of being relaxed while engaged in physical and mental activity. Dr. Bates held this principle as central to all creative endeavor, saying that the secret is to stay relaxed during activity.

Our vision is just like any of our activities: We perform it best when we are free of tension, yet active and alert. Full-color seeing requires the eyes to be relaxed and constantly moving. Often, our habits are exactly the opposite; when we want to see something better, we fix our vision and stare at it; we look harder at it. This only causes strain, which reduces our ability to see.

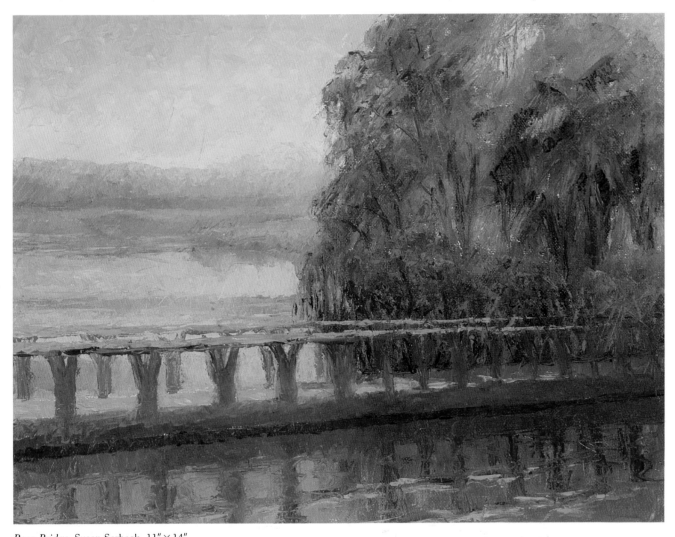

Boca Bridge, Susan Sarback, 11″ × 14″

As I worked on this painting, I continually scanned the scene, keeping my eyes gently moving. This enabled me to see the yellow-orange color of the sunlight on the bridge, the blue-violet of the bridge in shadow and the unusual warmth of the bridge's reflection in the water.

Scanning is my term for the relaxed, constantly moving vision that promotes full-color seeing. When we scan, the eyes sweep lightly across the field of vision, never locking on any particular object. The head moves gently back and forth, and the eyes move with the head. This motion can be subtle or pronounced and helps prevent rigidity and tension. Scanning is the opposite of staring. The eyes stay loose and gently keep moving over everything in view.

Before I learned the more relaxed vision of scanning, I sometimes became very tense as I worked. In art school, I noticed the same tension in other students. Some worked with severe concentration—with clenched teeth, locked jaws, and straining eyes. In marked contrast were those whose faces were completely relaxed as they worked. When I was tense, my work became tight and fussy, but when I relaxed, my work had more freedom and aliveness.

Today, I get my best results when I relax and scan. I use several techniques to relax my eyes and help myself scan when I paint.

Relaxing the facial muscles, especially the jaw, helps relieve strain in and around the eyes. Researchers, investigating why women applying mascara often let their mouths fall open, discovered a connection between a slack jaw and relaxation of muscles around the eye. When I paint, I often let my eyelids droop slightly and my jaw go slack; this helps me to relax and move into full-color seeing.

The Swing, Breathing and Blinking are other techniques for relaxing the eyes.

The Swing

The basic principle behind the Swing is that tension is not fully relieved by sitting or by lying down, but by doing something active, because muscular activity soothes nerves.

In her book, *Help Yourself to Better Sight*, Margaret Darst Corbett describes several exercises for entering into a state of dynamic relaxation. She describes the principles behind the Swing as:

These students at my School of Light and Color in California are doing the Swing, an exercise to relax the muscles in the body and eyes for improved color vision.

. . . a return to nature where rhythm in motion is the rule. The race horse in the stall weaves from side to side, the animals in the zoo sway back and forth, not from impatience but to soothe nerves and release tension. Wild elephants gathering in the jungle rock from side to side and swing their trunks rhythmically, weaving as in a dance. Immobility and rigidity are the products of civilization and the beginning of tension and nerves. So, free the large muscles of their tension first by rhythmic motion. These large voluntary muscles will transfer sympathetically their vibrations to the more minute involuntary muscles, including those of the eyes.

To do the Swing, stand with your feet shoulder-width apart and continuously turn your torso, shoulders and head from left to right and back in a semicircle. Pivot on the balls of your feet as your weight shifts back and forth. Let your arms swing freely. The shoulders and head move together, and the eyes with them, sweeping in an arc, without stopping to rest or focus on any one object.

Let your mind be indifferent to what it sees, making no effort to perceive. Simply swing back and forth, skimming your eyes lightly across everything in view. The objects in your field of vision will begin to slip past you as you move, almost like looking out the window of a moving train. Surrender to the rhythm as you would to a dance or a childhood game.

I often do the Swing about thirty to sixty times as a warm-up exercise to help my eyes relax before I paint.

Breathing and Blinking

Deep, steady rhythmic breathing is an ancient method of relaxation as well as a cornerstone of good health. It is also essential to sight, as anyone can demonstrate by holding the breath until vision dims. Unfortunately, many times we do exactly that; intent on a task, we hold our breath or breathe shallowly, reducing oxygen to the eyes and inhibiting our vision. We want to be able to focus our attention while remaining relaxed and continuing to breathe deeply.

Frequent blinking is another way to break the spell that we sometimes fall into while concentrating. Blinking moistens the eyes and helps keep the vision fresh.

Palming

When your eyes are tired, you will not see well. One way to give the eyes a rest when painting is to take a break and look into a dark, shadowy area. Another is to go indoors for a few minutes. Still another is a simple exercise called *Palming*.

We place extraordinary demands on our eyes — even the books and movies we enjoy in our leisure time require vision. Often, the rest our eyes get while we sleep is simply not enough. Palming is an exercise devised by Dr. Bates to completely rest the eyes. It can be done whenever the eyes need refreshment — before painting as well as during breaks.

Simply close the eyes and cover them with the palms, the bottom portions of the palms resting on the cheekbones and the four fingers of each hand overlapping on the forehead. Let the hollow of your hand leave room for the eyes to open or blink if they wish; don't press on the eyes themselves. You may want to shake or rub your hands initially, to loosen and warm them. The idea is to create a warm, comfortable, dark haven in which the eyes can totally relax. Several minutes of palming gives the eyes a chance to let go of tension.

The eyes and mind work together, so when you're palming, relax your mind as well. Give yourself a break from whatever mental chatter or concerns may have crept into your head. With this combination of mental and physical relaxation, your eyes will emerge rested and refreshed, ready to see again.

These students are practicing palming, one of the techniques used to rest the eyes.

PAINTING WHILE RELAXED

How does an artist paint using this relaxed vision? Suppose I'm painting a landscape by a river. To enter a relaxed, receptive state, I begin by doing the Swing, gently turning back and forth as my eyes move across the scene, never resting on any particular object. When I am looking to see color, I do not see water, rocks or tree, grass, hills or sky; I see only masses of color, one next to the other. After I do this for a few minutes, I am ready to begin painting.

I continue to keep my eyes moving, never locking on a particular mass or object. Staring into a color causes the eyes to register that color's complement as an afterimage, which makes it look duller, because mixing complements—like red and green, blue and orange, and purple and yellow—makes gray.

If we stare at a red apple, our eyes will supply green to complete the spectrum. Since green is the complement of red, the intensity of the red appears to diminish. Thus, the more deeply we look into that apple, the more the brightness of that red recedes from our vision. When we stare into a color, we neutralize our color vision, and everything looks duller than if we keep our eyes moving.

Instead of staring, keep your vision soft, shifting easily from object to object. Rather than looking into an object, glance across it, and look next to it, above it and below it. Move your eyes constantly across the whole scene. Always keep the eyes moving—an important key to full-color seeing.

If you paint in a relaxed, receptive state, you become open to a new vision of light and color. Your paintings will then begin to reflect clear, radiant color.

I paint directly from life. I took this photograph to show the scene painted below. One reason I don't work from photographs is that I can't scan and see the color in the photograph like I can when I'm actually working from life.

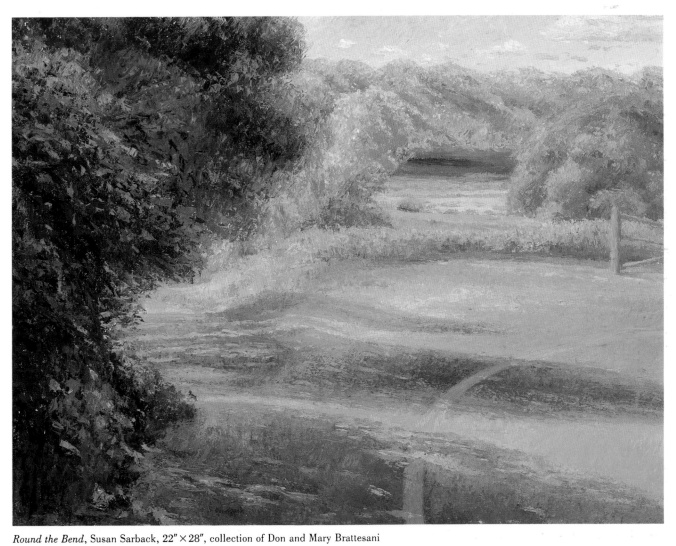

Round the Bend, Susan Sarback, 22″ × 28″, collection of Don and Mary Brattesani
This was a challenging scene. I had to stay relaxed to see the many subtle color changes. Notice how the yellow line in the road moves from green in the near shadow to bright yellow in the sun to a softer yellow farther back. Notice also that the shadows on the path do not follow what color theory would have us expect — the pinkish purple of the far shadow is actually warmer than the blue shadow in the foreground. Scanning helped me see these color variations.

SEEING WITH FRESHNESS

I once knew a man who lived consistently in a state of wonder. At the age of one hundred, he still maintained the wondrous vision of a child. He had a love for everything he saw, perceiving the simple beauty of a thing before its function.

One day, I handed him a large, common shell. He looked inside it, examining the variations of color and texture with loving eyes, looking as a child would, as if for the first time. He turned it carefully, noting each hue and convolution of the shell. I never saw anyone appreciate beauty like he did. His vision was remarkably clear and fresh.

Full-color seeing relies on this fresh vision—the vision that is willing to see everything as if for the first time. To be receptive to a new way of seeing, we have to not only relax but also open ourselves and make room for the new.

Often, we have to set aside our beliefs, preconceptions, judgments and preferences. Free of our old habits, we begin to see with renewed clarity.

When I started studying full-color seeing and painting, I thought I already knew quite a bit about color. It was only logical that a blue tabletop in sunlight would be light blue, and so that's what I saw. Later, I learned to see the traces of pink or yellow or orange. Before full-color seeing, I expected colors on a somber, cloudy day to have a dull, grayish cast, and I saw them accordingly. With full-color seeing, I learned to see the rich, deep colors that weren't gray at all.

Our perceptions come to us through the filter of our beliefs. Often our commitment to our beliefs and preconceptions is greater than our trust in the truth of our immediate experience. Full-color seeing means letting go of limiting beliefs and trusting our vision.

Summer Shadows, Susan Sarback, 20″ × 24″

Notice the warmth of the blue cloth in sunlight and the cool blue of the cast shadow on the cloth. If I had looked directly into the cloth in sunlight, I would've missed the traces of yellow, orange and pink and seen only pale blue, losing the feeling of a sunny day. I had to let go of the idea that a blue cloth will always appear blue, and simply trust my full-color vision.

PRECONCEPTIONS

Let's look specifically at how our beliefs affect what we see. Some of our beliefs are taught to us, and many are formed by generalizing from our experience. We make generalizations to help us function in everyday life. For example, every time we enter a new building, we don't have to examine the front door to determine if it operates similarly to other doors. We simply walk through. "Seen one, seen 'em all," the mind assumes.

This tendency to generalize can be a hindrance as we paint. "Don't bother looking at that apple," the mind will tell us, "No need to waste precious time. I already know apples are red." Or a slightly more painterly version, "No need to see the shadows, I've got them all figured out for you. They're always cool, usually blue-purple." The mind will tend to summarize experience into a rule until it is trained otherwise.

To see in full color, we must let go of these general beliefs and simply allow ourselves a direct experience in the moment. This is a state of freshness and wonder. From it, discovery and beauty emerge.

Painters often carry beliefs that limit their experience of this fresh vision. I remember once watching two beginning students set up an outdoor still life. A wide strip of dirt appeared in the backround of their composition. "I don't want to paint dirt," each said. They did not see its simple beauty—deep violet in shadow and a rich, warm reddish color in the sun. When we let go of the way we *think* something is and open to the direct experience of our vision, we can see the full range of light and color.

Often, we don't realize our limiting assumptions until we begin to try to see without them. Beginning students of figure drawing are often amazed to learn that the eyes are positioned not in the upper part of the head, but in the center. Our view of color in nature is subject to the same kind of preconceptions—trees appear green, the sky blue. But we can discover a variety of subtle colors, some strikingly different from the obvious. A white bowl in sunlight at first appears white in the sunlit portion, and simply dark or gray in the shadow portion. With full-color seeing, a painter may see beyond these everyday expectations and catch perhaps some pink, yellow or orange in the sunlit part, and in the shadow area, blues, violets and greens.

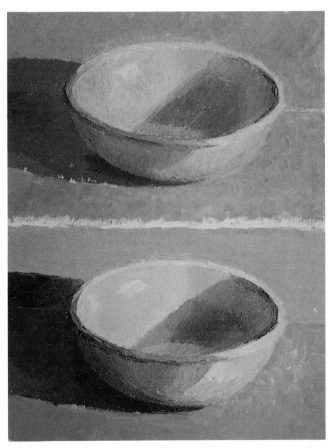

Full-Color Seeing Compared to Local Color. The top bowl is painted using full-color seeing; the bottom bowl shows local color. Compare each area of the two paintings. The picture exemplifying full-color seeing has colors we might not expect in a pure white bowl. The top bowl has areas of blue, yellow and violet, whereas the bottom bowl has only shades of gray. Also, I saw the cast shadow in the top picture as magenta, but in the bottom picture, it's just the local color of the ground cloth mixed with gray.

SEEING AS IF FOR THE FIRST TIME

American painter Fairfield Porter knew the value of a fresh vision: "I painted a view recently. A great big painting. And it's because I looked out a window and saw it as if for the first time, in a new way. . . . What I admire in [one artist's] paintings is that they remind me of a first experience in nature, the first experience of seeing. . . ." In speaking of the Spanish painter Velázquez, Porter said: "He leaves things alone. It isn't that he copies nature; he doesn't impose himself upon it. He is open to it rather than wanting to twist it." (*Fairfield Porter*, Boston: Museum of Fine Arts, 1987)

Monet went so far as to say that he wished he'd been born blind and then had suddenly gained his sight, so that he could have begun to paint without knowing anything about his subjects. He held that the first real look at the motif was likely to be the truest and most unprejudiced one. This is the attitude behind full-color seeing.

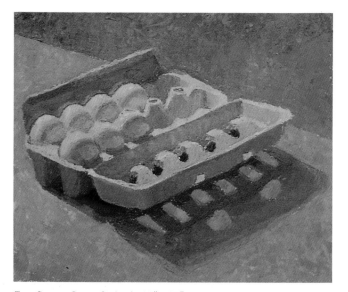

Egg Carton, Susan Sarback, 12″ × 13″
The fresh vision of full-color seeing can transform ordinary household items into objects of radiance and beauty. This study of white eggs in a gray carton shows the full range of color found on a sunny day.

Sunspots, Susan Sarback, 24″ × 20″
This is a backlit painting of two vases of translucent, frosted glass. At first, I didn't even notice the round spots on each vase created by the sun shining through the top opening—I'd never seen that effect before. But when I looked with a fresh vision, I saw how intense and luminous they were.

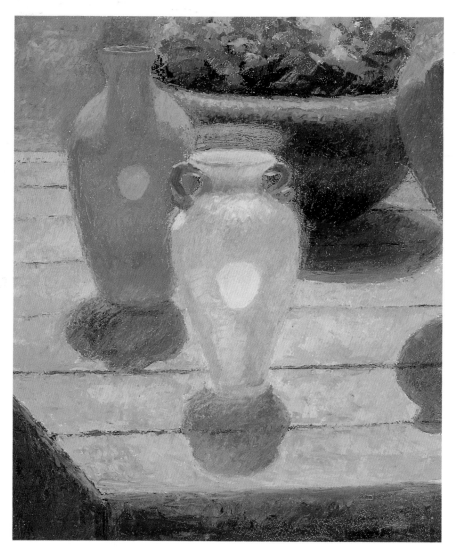

PREFERENCES

"Taste is the enemy of creativeness," said Picasso. Suppose you dislike the color yellow. You may tend to overlook yellow when you paint. The yellow on your palette may rarely be touched. Or, conversely, perhaps you prefer the warm end of the spectrum—the yellows, oranges and reds; you may then have a harder time seeing the cool colors. While learning full-color seeing, it is useful to drop color preferences and aversions.

My own preferences tended toward muted, cooler colors. I specifically remember the difficulty I had as a student learning to see warm colors in shadows, especially shadows on grass. I saw green, with touches of blues and purples, but I saw no hint of warmth. Along with preferring cool colors, I had the notion that shadows consist of merely cool colors. I didn't quite believe there could be any trace of red or orange in a lawn in shadow, so I didn't see any.

Only after careful study of paintings I admired did I open to the possibility of other colors in the shadows. If other artists had seen warmth in shadows, then perhaps I could, too. Of course, opening to this possibility did not instantly change my ability to see warm colors, but it was a starting point. Occasionally, as an exercise for myself, I chose subjects that were extremely warm, bright and bold. This helped me overcome my preferences and learn to see the entire spectrum of color.

Adobe Fountain, Susan Sarback, 24″ × 18″
I chose a bold subject of bright, warm colors to help me go beyond my preference for subdued, cooler colors. The warmth of the orange flowers and the adobe wall, as well as the full sun of a hot summer day, made it easy to see and appreciate the warm end of the spectrum.

Tomatoes on White, Susan Sarback, 20″ × 24″

Here is an example of a painting that could be used to explore the color red. Even though the local color of ripe tomatoes is all red, these tomatoes show a range of color. Painting studies of single-colored objects helps one to appreciate and learn about that specific color, as well as to learn to see subtle variations in color.

MOVING BEYOND LIMITS

A beginning student in one of my workshops was not seeing red. His paintings included the rest of the spectrum, yet he was unaware that he was avoiding red. First, I helped him see, to his surprise, that he had used every color on his palette except red. I then suggested that he paint several studies of red objects. He painted on cloudy days and on sunny days so that he could see red in different kinds of light.

By putting sustained attention on seeing red, he finally overcame his dislike, and in doing so, broadened both his appreciation and his vision. In painting ripe tomatoes, he saw the beauty of the color, its variety of rich, deep notes.

You can begin to identify your preferences by examining your paintings. Also pay attention to other times when you make color choices — clothing, interiors, works of other artists you enjoy. Notice if your choices lean toward the cool

side, the warm side, high contrast, neutrals, light, dark and so forth.

Often when painters rely heavily on certain colors, there are other colors being neglected. For example, the painter who avoided red was overusing orange and violet. If you have a preference, make a special effort to explore other color choices. If you have a color aversion, make a point to use the color until you become comfortable with it. In this way, you expand your appreciation and experience a greater variety of beauty.

A NEW WAY OF SEEING

One day after class, one of my students called me on the phone, her voice full of excitement. She said that when she got home she saw a blue spot on her stainless steel sink. Thinking something had spilled in the sink, she got her cleanser and began scrubbing vigorously, trying to clean it up. Finally she realized it wasn't coming off — there wasn't anything on the sink at all. She was simply seeing the blue color from the way the light touched the stainless steel, a color she'd never noticed before. Pleased and surprised, she told me, "I had no idea this workshop could so completely transform my day-to-day vision."

This vision of full-color seeing is marked by curiosity, wonder and the ability to see each object as something new. Labeling things can stop us from seeing what they really are. Painters can form the habit of seeing objects — just shapes and colors — without attaching names. I had an experience one day that showed me the difference this fresh vision can make.

As I was stopped at an intersection, I happened to glance over at a manhole cover. I thought, "What a common, mundane object." It was just a thick, dense slab of metal. But then I switched to my painter's vision, full-color seeing. I looked again at the manhole as if I were going to paint it. I noticed that the raised lettering on the cover captured the sunlight in interesting ways. I saw patterns of light, shapes and colors.

It became more and more beautiful. Instead of a manhole cover, it became like a Mayan sun symbol, radiant and glowing. In only a moment, I had moved from my everyday world into a world of deep beauty, just by shifting my vision. When I dropped my expectations about manhole covers, I had a new and greater perception.

To paint with the freshness of full-color seeing, it helps to be curious, take breaks and trust your vision!

Be Curious

Explore and discover. When we look at something as though we're seeing it for the first time, it's always a sur-prise. We are open to seeing things we've never noticed before — like the woman who saw the blue spot on her sink. A deep curiosity about life transforms everything into something special, helping us to love seeing and to love life, giving us the key to seeing beauty in all things.

Take Breaks

To keep your vision fresh, take occasional breaks from your painting. You can walk away from your scene in order to return and see your painting as if for the first time. You can do seeing exercises, such as the Swing, described earlier to release tension and move into a receptive state. You can stop, close your eyes and clear your mind, perhaps using a relaxation technique, such as deep breathing or palming.

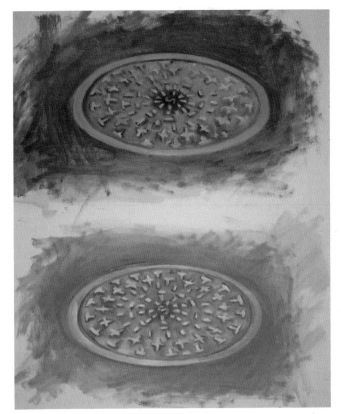

Manhole Cover, Susan Sarback, 20″ × 16″
These two studies are of the same subject, a manhole cover on a sunny day, but each is painted with a different vision. The first was painted using my everyday vision, the second, using full-color seeing. Notice how the first version misses the radiance and intensity of direct sunlight. Full-color seeing is the key to capturing the effects of light.

Trust Your Vision

In one of my weekend workshops, a painter was struggling with a study of a lavender bowl in direct sunlight. He had painted the shadow side of the bowl a blue-green. Exasperated, he called me over. "I'm losin' it," he said. "I just can't do it." I glanced at the bowl and back to his painting, and saw, to the contrary, that his color was quite accurate.

Trust your vision. Assume that your initial impressions are correct and go with them. Don't concern yourself with being right or wrong; the process is one of continual refinement.

Often, we rely heavily on our intellect to solve our problems. It takes trust and courage to allow the solution to emerge directly from our sensual experience. This fresh vision is the source for growth into a mature perception. As painter Charles Hawthorne expressed it, "We must train ourselves to keep and preserve our fresh and youthful vision along with all the experience of maturity."

Lemons on a Black Plate, Susan Sarback, 20″ × 24″
collection of Terri Todd
I was surprised by the full spectrum of color I saw in the black plate in this painting. I'd never painted a flat, black object in sunlight, and as I worked I became fascinated by the range of deep, rich color. Notice the variety of colors in the shadows and reflections of the lemons on the plate—all mixed without using black.

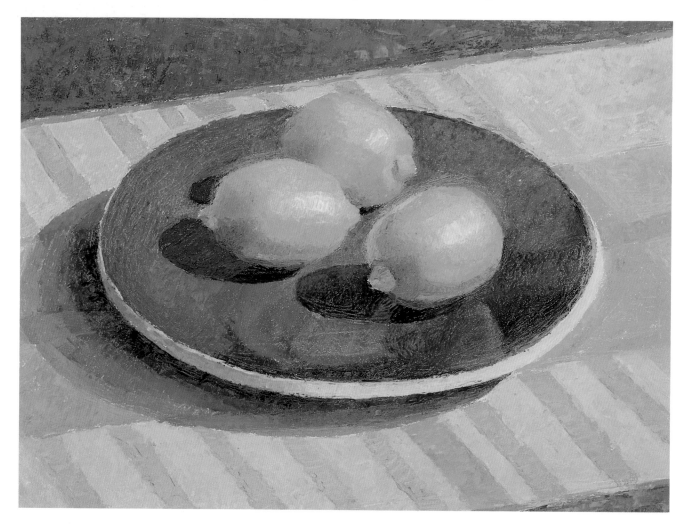

August Garden, Susan Sarback, 11″ × 14″
This painting is a small, intimate view of a summer garden reflecting in a still pool. It doesn't have a dramatic center of interest or an elaborate composition—its charm rests on the pure, fresh colors that capture the warm August light. A sense of curiosity and wonder can make the simplest of subjects interesting.

TIPS

For Seeing With Freshness

1. Keep eyes, jaw and face relaxed.
2. Scan your subjects. Keep your eyes moving.
3. To see color, don't look directly into your subject.
4. Be aware of your preconceptions. Don't rely on what you *think* the color *should* be.
5. Be aware of your color preferences and aversions. Experiment with a wide range of color.
6. Look at things as if for the first time.
7. Take frequent breaks.
8. Develop your sense of curiosity and wonder.
9. Trust your vision. Don't be afraid to make mistakes. It's only paint; you can always change it.

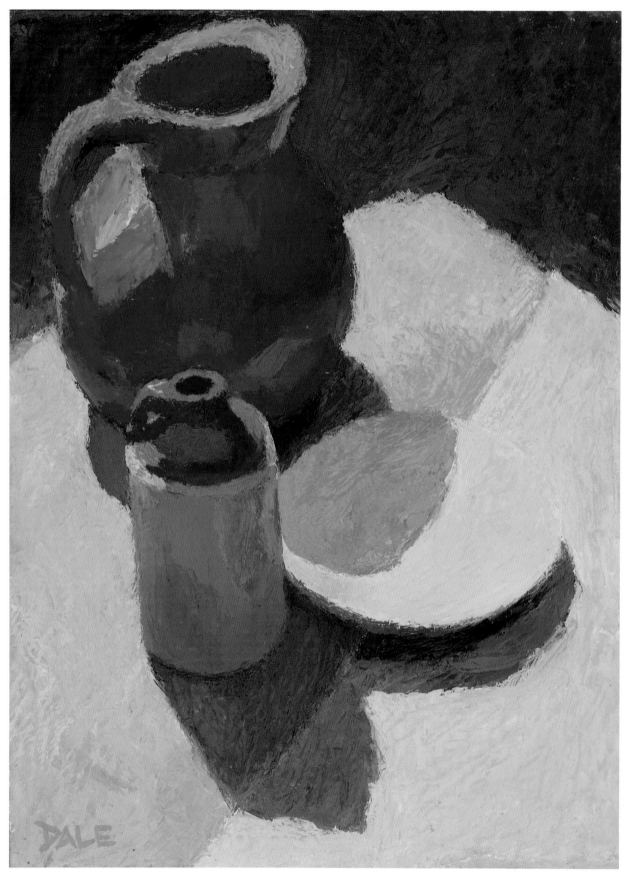

Still Life in Sunlight, Dale Axelrod, 16″ × 12″

PAINTING A SIMPLE COLOR STUDY

When you go out to paint,

try to forget what objects you have before you . . .

merely think here is a little square of blue, here an oblong of pink,

here a streak of yellow, and paint it just as it looks to you.

CLAUDE MONET

Color expresses something by itself,

one cannot do without this, one must use it;

that which is beautiful, really beautiful — is also correct.

VINCENT VAN GOGH

The successful painter is continually painting still life.

CHARLES HAWTHORNE

C olor studies are the crucial ingredient in the process of learning full-color seeing. A *color study* is a painting done for the express purpose of studying the effects of light and color. The emphasis is on seeing and painting color, not on complex compositions, or intricate, detailed forms. When doing color studies, don't worry about making finished paintings; simply practice seeing and painting. Just as musicians practice scales as a foundation for their music, painters do color studies to gain fluency in the language of light and color.

Block Study in Sunlight
John Ebersberger, 16″ × 12″
This is a quick block study done to capture the effect of a sunny summer day. Studies like this are the foundation of learning full-color seeing and painting. Notice the simple subject matter and the reliance on color to create light and form.

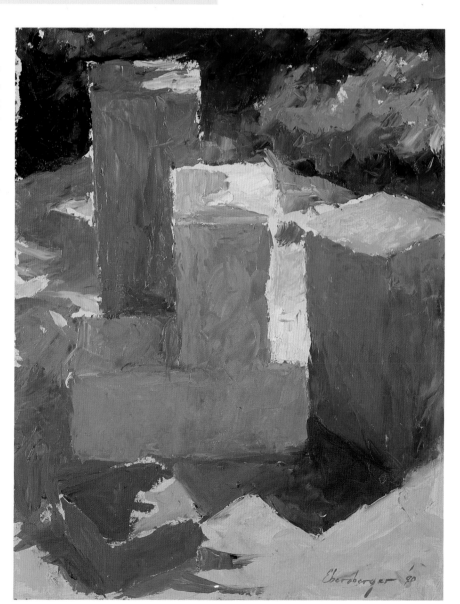

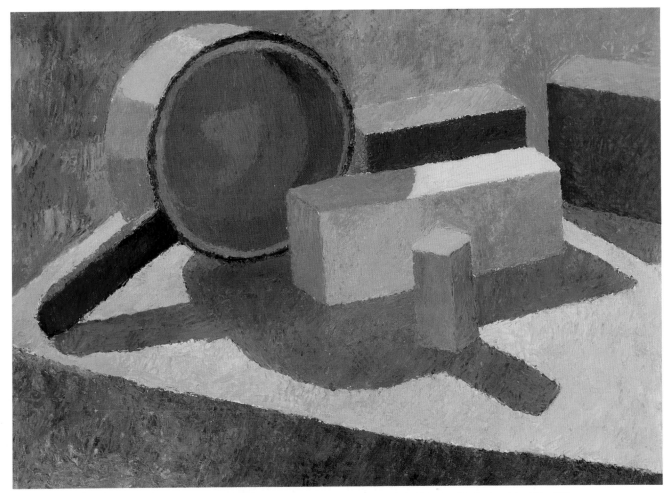

Afternoon Still Life, Camille Przewodek, 12″ × 16″
This painting has been more fully developed than the quick block studies. It also has a rounded object, the pan, which is more challenging than blocks. Notice the variation of color in the long white block in the center.

BEGIN WITH BLOCKS

The key to beginning a color study is to start by seeing relationships of simple color masses. As a student, I learned to use colored wooden blocks as still-life setups for studying color. That way students can see flat masses of color planes without being distracted by complex forms and color patterns. Later, students advance to rounded objects, more complex still lifes, portraits and landscapes.

Courses in art schools often have students paint similar block studies. Beginning painting classes teach how to see value differences between the sides of the block; an orange block would appear to be light orange in the light plane and a darker orange in the shadow area. But this is not what full-color seeing reveals. It shows color differences, not just value differences. When students first see these color differences, it is a revelation. An orange block may be yellow in sunlight and magenta or violet in shadow.

SUPPLIES

I use oil paints because of their flexibility (i.e., colors can be altered easily and rapidly) and for the range of colors they offer. However, some people prefer the convenience and lower cost of pastels. Students usually paint outdoors under natural light, using the most favorable conditions for seeing full-spectrum color; they work with simple relationships of colors in sunlight and in shadow. For indoor painting, I recommend using halogen lights or working next to a window.

I use Winsor & Newton paints, but any good-quality brand will do. The basic colors I recommend for a palette are as follows: titanium white, cadmium lemon, cadmium yellow, cadmium orange, cadmium red, permanent rose, Winsor violet or dioxinine purple, ultramarine blue, cobalt blue, manganese or cerulean blue, cadmium green, and viridian. This is a good palette to begin full-color seeing and painting.

Here are some additional colors you may want to use later on: cadmium yellow pale, cadmium yellow deep, bright red, cadmium scarlet, permanent magenta, permanent mauve, Winsor emerald, cadmium green pale, bright green, yellow ochre, Indian yellow and burnt sienna.

This palette includes a full range of warm and cool colors as well as bright and deep colors. Generally, warm colors are reds, oranges and yellows, and cool colors are blues, blue-greens and blue-purples. Colors like green and violet can be warm or cool. A yellow-green would be warm, but a blue-green is cool. Of course, in a painting the warmth or coolness of a color is largely determined by the colors surrounding it; a yellow-green would look cool next to orange and warm next to blue. Colors are always relative to each other.

Most of the colors on this palette have a cooler version and a warmer version. For example, lemon yellow is cooler than cadmium yellow, ultramarine blue is cooler than cerulean blue, and permanent rose is cooler than cadmium red.

I do not include black on my palette as it deadens my colors. You can achieve deep, richer colors by mixing from the colors on this palette. Experiment and practice mixing colors. Any given color can be mixed in a multitude of ways, so I stay away from giving formulas to encourage students to respond with freshness to the colors they see in their subject.

When I first studied light and color, I was taught to paint with a palette knife. When students start with brushes, they tend to fuss with details. The knife forces students to paint in larger, simpler masses, which is appropriate for learning color. Keeping brushes clean from color to color is difficult because the previous color mixes with turpentine or other media and stays in the bristles of the brush. A knife allows

the artist to keep the colors pure because no medium is necessary; the artist can easily wipe the knife clean between colors using a paper towel or rag.

If you paint with a palette knife, make sure it is fairly flexible. Use the side of the blade, not just the tip, to apply paint. Don't dab or poke the paint onto your painting; spread it on more like buttering toast. Experiment to find the method you like best.

Most students who use a palette knife prefer to paint on gessoed Masonite board instead of on canvas. Later, as you become more adept at the process, any medium — acrylics, watercolors, colored pencils, or any tool (including brushes on canvas) — can be used. I still use a palette knife most of the time, because I like the convenience and clarity of color.

The colors on this palette are in the order of the spectrum. There is adequate space so that the colors stay clean. I use a small, wooden palette and rest it on my painting box during outdoor painting, because I like to have both my hands free.

It's best to do beginning color studies with a palette knife, also called a painting knife. This way, you keep the colors clear and fresh and prevent focusing on details prematurely. Palette knives come in a variety of shapes and sizes. The blade should be flexible. You may want to experiment to find the kind you like best.

STATING THE MAJOR MASSES

To begin a color study, set up a still life of simple objects with the light creating cast shadows. As a beginner, avoid the challenge of patterned surfaces and glossy, reflective objects. Don't worry if your subject initially seems uninteresting; your real subject is light and color, which is always surprising and beautiful.

Next, quickly sketch your composition onto your canvas or gessoed Masonite board. Don't do a detailed drawing; see your composition in terms of a few simple, large forms. These are the major color masses of your painting. If an object is half in shadow and half in light, it breaks down into two different color masses. The underlying strength of a work is in the relationship of the major masses. No matter how many details are added later, the strength of the color in a painting rests on the color relationships of the major masses. This structure supports the entire painting.

After the sketch, you are ready to begin laying in the color of each major mass. First, "scan and compare." Moving your eyes over the setup and comparing color masses, scan for your initial color perceptions. Instead of looking directly into an object, and seeing only local color, compare the color of the object to the surrounding colors as you scan. The color of each form is revealed through its rela-tionship to all the others. Sometimes a color may flash out like a burst of neon; other times it dawns slowly after repeated comparisons. By scanning and comparing, you are able to see the color of the object as affected by the pervading light.

Make your best approximations of the main color masses of the painting, working quickly to have them all initially stated within the first fifteen minutes. Because all the color notes influence each other, it's easier to see what you have once they're all stated.

Put one flat color for each mass. Determine a unique color for each color mass. This helps you see specific color differences and to avoid generalization.

Don't paint to the edge of the mass; leave unpainted spaces between masses. Since you will be going over these masses several times to improve the color relationships, you don't want to fill in the edges too soon and cause colors of adjacent masses to blend right away. If they blend prematurely, the colors get muddy.

Start with a color mass you can see well, working by comparison one by one to adjacent masses until the whole canvas is covered. For example, for a block in sunlight, you may start with the top of the side in sunlight, then move to the side of the block in shadow, then to the cast shadow, and so on until all the masses are stated.

Block Study, 11″ × 14″

Two blocks of different colors are the best subject for a beginning study. This is a study of an orange block and a yellow block in full sunlight. Notice how every side of each block is a unique color, as are the cast shadows.

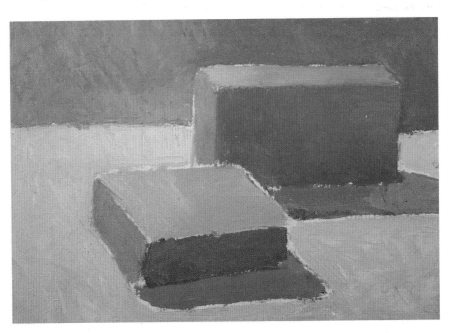

DEMONSTRATION
Basic Block Study—Seeing and Painting Color Masses

Basic block studies are the foundation of learning full-color seeing. This study shows a variety of colored blocks in direct sunlight, although two or three blocks are enough to start. The blocks make it easy to see color in terms of masses.

With full-color seeing, color masses, rather than values or linear drawing, are used to describe form. Simple subjects like blocks have clearly defined major color masses. Usually, each side of a block is a distinct color mass, unless a side is partially in sun and partially in shadow, in which case it may be two color masses.

The color of each major color mass is determined by seeing color relationships. Each mass is compared to its adjacent masses and to other masses in the painting. When comparing, look for specific differences between the masses.

See and paint the light plane and shadow plane distinctly different from each other. See the differences as changes in color, not just value. All of the color masses in the light plane should hold together as being sunlit, and all of the shadow plane color masses should hold together as being in shadow. After your initial statements of the color masses, you should be able to glance at your painting and see light and shadow.

I do block studies on gessoed Masonite, usually relatively small, about 11″ × 14″ or 12″ × 16″. This makes it easier to modify colors quickly. When arranging objects for a still-life study, include major areas of both light and shadow. Paint a wide variety of colored objects, starting with straightforward colors like reds, blues, yellows and greens. Black and neutral-colored objects tend to be a bit more difficult for beginners to see.

I have divided the process of painting a study into five major steps: sketching the major masses, stating the major masses, refining the major masses, color variations and final development.

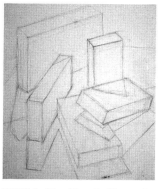

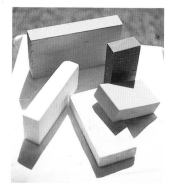

This is a photo of a block study setup. A simpler study would have fewer blocks, but I chose several colored blocks to show how a variety of local colors are affected by light. Notice that the light comes from behind with shadows falling toward the viewer.

STEP 1. *Sketching the Masses.* Do a quick sketch of your subject, focusing on the large, simple shapes that make up your composition. These major masses, in this case, are the sides of each block, the cast shadows, the tabletop and the background.

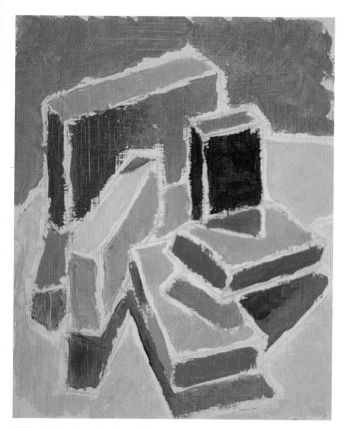

STEP 2. *Stating the Major Masses.* The second step of a study is to lay in the colors of the major masses, establishing the light planes and shadow planes. Each mass is initially painted as a single, solid color. To keep the colors clean, I leave white space around each mass. As the masses are developed, the color masses meet at the edges. The colors are seen by scanning and comparing color masses. For example, in order to see the blue-green shadow end of the white block, I compared it to the top of the block in sunlight and to its cast shadow on the tablecloth.

STEP 3. *Refining the Major Masses.* The third step of a study is to refine the initial statements of the major masses. I continued to scan and compare the masses, making modifications to each one to make it more accurate. For example, the forward end of the yellow block was initially a warm orangish ochre color. As I scanned, I saw that it was actually greener, so I changed it. It may take several such modifications to make each color truer.

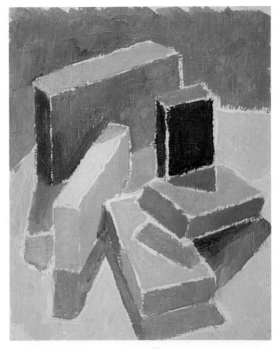

STEP 4. *Color Variations Within a Mass.* When the major masses are stated as accurately as possible, it's time to move on to variations within a mass. Variations are color divisions, or shapes of color, within a mass. For example, the shadow side of the gray-green block in the back is no longer a flat area: It now has four divisions of color. See and paint the simple, more obvious divisions first.

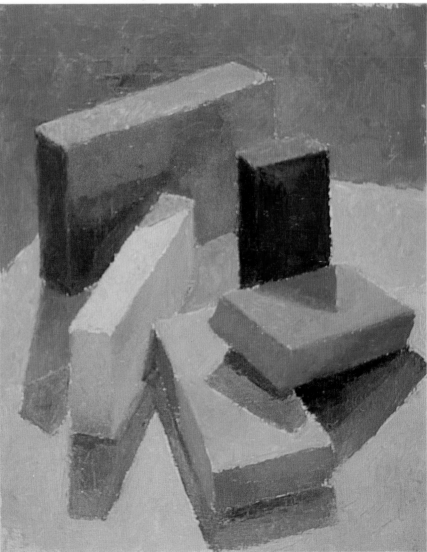

STEP 5. *Final Development*. In the final stages of a painting, you may see more variations within each mass. If your painting has dried from a previous session, you may want to scrape down the ridges and bumps with your palette knife to make a smooth surface to paint on. When I paint wet-on-dry, I sometimes let the underlying color show through to varying degrees. Other times, I simply restate the area of color that needs work.

Notice the variations in the cast shadow of the white block as it falls on the tablecloth and the cast shadow of the red block onto the yellow block. Notice also how the edges of each block have more variations than in the previous steps.

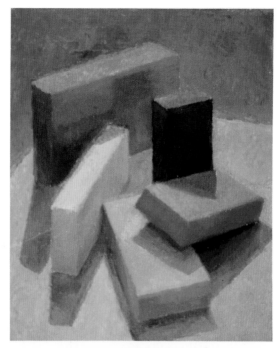

Cloudy Day Block Study, 14″ × 11″
This is a painting of the same setup on a cloudy day. Compare the colors of the masses to the sunny-day version, and notice the differences. Generally, the sunny-day colors are warmer and brighter. By using full-color seeing, I saw how the colors of the same objects changed from a sunny day to a cloudy one. Even though it's a cloudy day, the full spectrum of colors is present.

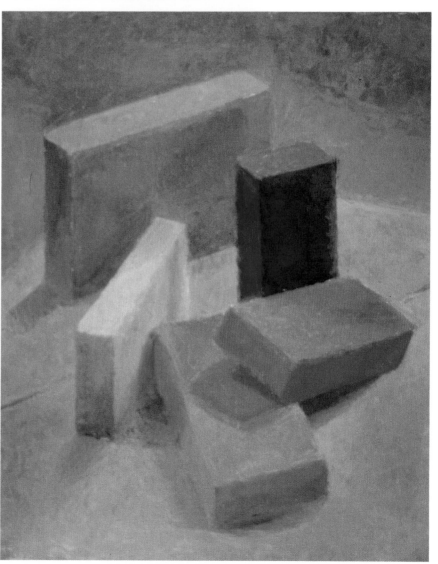

Establish Light and Shadow

As you make your initial color masses, notice which surfaces are in light and which in shadow. Clearly establish the major pattern of light and shade with your initial color statements. Look for the big, overall pattern. Sunny days will have the clearest distinction between sun and shade. In general, the light plane will be warmer and lighter than the shadows, which tend to be cooler and deeper. Of course, as the painting develops, you will notice traces of coolness in the light planes and warmth in the shadows, but for your initial statements, it's often easiest to see the light planes as warmer and the shadows as cooler. Remember to use your vision to scan and compare each note. Some light-plane areas may actually be deeper than other shadow areas.

Full-Color Spectrum

The full-color spectrum is always present in natural light. This is apparent when we see a prism breaking white light into the seven colors of the rainbow. Full-color seeing helps us see the full spectrum of color present everywhere. This does not mean that colors appear in bands like a rainbow, but a painting done with full-color seeing will often contain all colors of the spectrum. Some paintings may seem to have only a few main colors, but usually the full spectrum is subtly present.

Trust Your First Impressions

Do not labor excessively over each color; trust your first impressions. As the painter Charles Hawthorne told his students:

> Perhaps we analyze too much. Try putting down your first impressions more. Do what you see, not what you know. Put down each spot of color truly and sincerely—remember that it is the large spot of color that tells the story. Make the big note and make it true.

After your initial statements of the major masses, you will refine their color relationships before going on to a more detailed level. Again, the painter Charles Hawthorne has invaluable advice:

> The weight and value of a work of art depends wholly on its big simplicity—we begin and end with the careful study of the great spots in relation to one another. Do the simple thing and do it well. Try to see large, simple spots—do the obvious first.

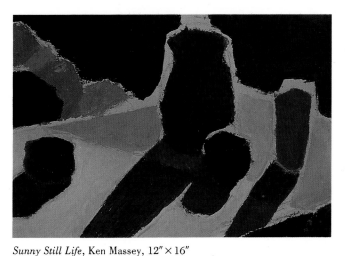

Sunny Still Life, Ken Massey, 12″ × 16″
Painted on a bright, sunny day, this study shows a clear distinction between sun and shade. Here the study is in the first stage, showing the initial statements of the major masses. In this case, the shadows were noticeably cooler and deeper than the light planes.

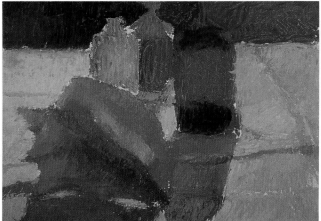

Study With Shell, Stephen Craighead, 9″ × 12″
The fresh colors in this study are not what might be expected. The local color of the shell in shadow was creamy white, but by trusting his vision, the artist was able to see the green color of the shell in shadow. The artist consistently focused on the major color notes, rather than details, to capture a sense of light and form.

REFINING THE MAJOR MASSES

Because the color relationships of the major masses are the foundation of a painting, it's important to see them accurately. The right relation of the masses creates the integrity of a painting. Take as much time as needed to refine these relationships.

After making an initial color statement for each major mass, begin to modify the color masses, making them more accurate. Work by making comparisons, improving your initial statements as you see the colors better. Continue scanning, comparing each mass to all the others and checking it against the whole. Rather than trying to mix the exact color on your palette, think more in terms of what color is needed to add to what already exists on the canvas.

Suppose you scan and see violet in a shadow mass, and you have blue already on your canvas. If your paint is still wet, you may simply add red to the mass on your canvas, since red and blue make violet. After you add a bit of red, scan again and check your painting to see if the change made the color more accurate. Until a color is seen in relation to all the rest of the colors of a painting, it is difficult to determine its accuracy. Consequently, much of the mixing of the paint is actually done on the painting itself. Each mass will undergo several modifications as you find the correct color.

To continue working on a painting that has already dried, I scrape the surface with my palette knife to remove ridges and bumps; in doing so, I regain the smooth surface I need to continue painting. Otherwise, the surface gets too uneven to work on easily. When I paint wet-on-dry, I sometimes let the underlying color show through to varying degrees. Other times, I begin by restating the area of color that needs work.

There are very few bull's-eyes in this way of seeing and painting. Only by looking, trying the color you see, and looking again will you know for sure. It is a constant process of adjusting each color in different color directions until the right relationships are struck.

Continue the process of comparing masses — brighter or deeper and warmer or cooler — until the relationships on your canvas are as close as possible to the relationships you see. All this time, keep your eyes in motion, blinking, scanning, comparing and staying relaxed and receptive enough to see the color relationships.

These colors will often be more radiant, luminous and fleeting than the obvious local colors. You may change the masses five or six times before being satisfied that you have reached the current limits of your vision. Even though I sometimes use words like *accurate* and *correct* in describing this way of painting, these terms are relative to each painter's development. For beginner and professional alike, there is always another step in the refinement of color perception.

Once you've achieved a good sense of the right color relations of the major masses, you'll be ready for the next step, working with variations within a mass.

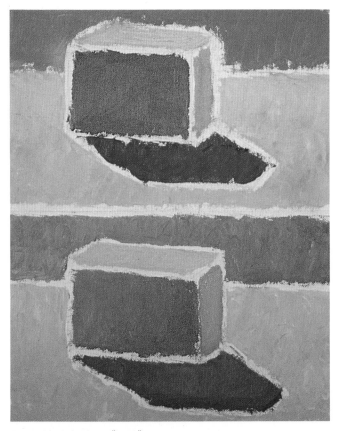

Single Block Study, 14" × 11"
The top block shows the initial color masses of a yellow block on a peach-colored cloth in sun. I saw the top of the block yellow, the shadow side green, and the cast shadow magenta. The bottom block shows my first modifications to the major masses. I scanned and compared, and saw that the shadow side of the block looked warmer compared to the cast shadow, which now looked cooler. I made these adjustments, mixing in some orange to the green shadow side of the block and adding blue to the magenta cast shadow.

VARIATIONS WITHIN A MASS

Variations in a mass are smaller subdivisions of color within the major color masses. They are seen in the same way as the major masses themselves. By scanning and comparing, you can begin to see color divisions within each of the major masses. For example, in the shadow side of a block, you may at first notice one side is warmer than the other. The cast shadow may be mostly one color closer to the block, and change near the edges; the ground cloth may vary from one side to the other.

Even though you may see a number of very small divisions in a mass, it's best to hold back and paint the major divisions first. Once, as a student, I was studying the color variations within the shadow side of a large clay urn. I saw perhaps a dozen different colors within that single color mass. I got very excited, as I had never seen such a variety of color. I immediately made a color note, or spot of color, on my painting for each variation I saw. An advanced painter came by and told me that I had jumped ahead of myself. I needed to get the major variations before breaking the mass into lots of little pieces.

Based on what you see, divide the mass into two or three different color variations to start. When these are as accurate as you can manage, paint the next level of divisions. If you don't get the major variations correct, the smaller ones won't hold together in their correct relationships. As you progress to increasingly smaller variations, don't make too many variations in one mass before developing the other masses. The painting is developed as a whole, not section by section.

One challenge in stating the variations within a mass is to make them clear enough to be evident, but not so extreme that the integrity of the form is destroyed. Even though the color may shift across the side of a block, when we paint the variations, we still want it to read as a flat plane. If the variations are too exaggerated, it will no longer look like a block; make them too subtle, and they will be lost.

Keep in mind that outdoors, in full sunlight, at close range, the distinctions we make are more easily seen than when we view the same painting indoors from across the room. For this reason, it is a good idea to occasionally back away from your painting and view it from a distance, and to see how it appears indoors.

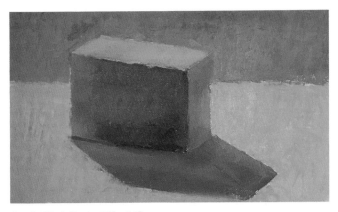

Single Block Study, 11″ × 14″
This shows variations within the major color masses. Notice the orange and violet in the magenta shadow and the greens, yellows and oranges in the shadow side of the yellow block. Notice the cloth is deeper and warmer on the left than on the right.

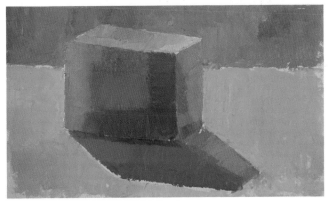

Single Block Study, 11″ × 14″
This study shows a pitfall to avoid when making color variations — the color variations within the masses are so extreme that the form begins to break down. The orange note in the middle of the side of the block pops out of the shadow mass. The painting begins to look like a flat patchwork quilt instead of a three-dimensional block on a table. If this happens as you are painting, restate the entire mass as a single color, and begin again, seeing variations.

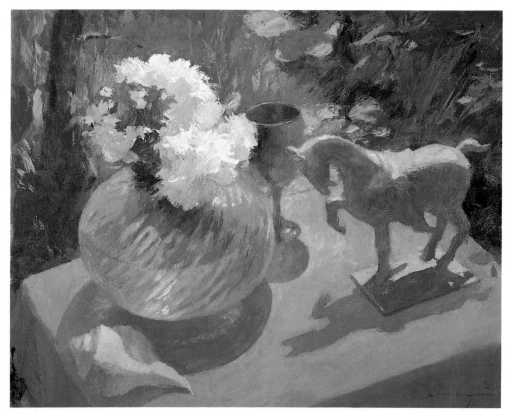

Amber Vase With Chinese Horse, John Ebersberger, 20″ × 24″
This painting has detailed forms, yet they are approached the same way
as in block studies—with a focus on seeing color masses and variations
within each mass. The details are created by refining color variations,
not with drawing and shading.

Let the Details Take Care of Themselves

Students commonly want to paint details first. This is like
trying to frame windows before laying the foundation, or
putting on makeup before showering. For example, when
painting buildings, beginners tend to immediately note ar-
chitectural details, such as doors and windows. This will
quickly establish the image as a house, but it does not help
in capturing a light effect.

Don't concentrate on describing details. As you work
with more color variations within a mass, the variations
themselves create the details. Be concerned first with get-
ting the correct color divisions and relationships. By seeing
the details simply as increasingly smaller variations within
a mass, you make the painting out of light and color rather
than out of a description of the physical subject.

With full-color seeing, attention is on the nature of light
revealed as it falls on physical form. A realistic likeness
occurs naturally as you paint the smaller and smaller color
variations within each mass. These variations of color build
the forms in your painting.

DETAIL. Notice the color variations in the vase. The impression of
sunlight on a swirled amber vase was created purely out of patches of
color. The flowers are not painted petal by petal; they, too, are seen as
color masses.

See Distinct Color Notes

When working with color variations in a mass, you will see finer and finer color distinctions. Painter Henry Hensche once used the analogy that, just as in music where the good musician knows that every note is distinct, in painting, every color note is distinct. "The lazy painter slurs," he said, "Every shape change is a color change."

All the variations within a mass can be seen as specific shapes with distinct colors. These could be hard-edged or soft-edged shapes, but they are clearly visible. Hensche taught that the color variations have unique colors:

> The fascination of this study of visual life lies in the fact that there is no repetition of any color combination. . . . When you find a duplication of any color in any area, it means you have not perceived the difference and could not separate two color notes that are close together.

In your color studies, you will explore making finer and finer variations. Later, you may choose the extent to which you make variations within each mass of the painting—sometimes there is a greater eloquence in simplicity. I suggest that students first gain experience with the full range of variations before weeding out the nonessentials.

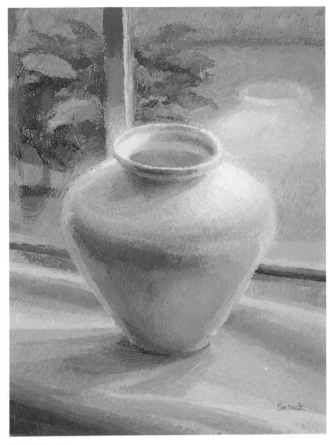

The White Vase
Susan Sarback, 14″ × 11″, collection of David DeLapp, D.C.
Notice the distinct colors in the shadow side of this vase. It was painted on a cloudy, overcast day, when color differences tend to be more subtle, yet each color variation is a specific shape. The colors are not blended together to make the form—rather, the roundness emerges from the specific colors and shapes.

Summer Pots (detail), Susan Sarback, 16″ × 20″
This study was painted on a series of hazy summer mornings. The colors in the pots show how each color variation is a specific shape and color. The shadow of the neck of the pitcher is greenish compared with the shadow of the opening of the pitcher, which is reddish; the top plane of the body of the pitcher is more violet. In general, when color variations are seen clearly, each subdivision of the mass will be a different color—none of the colors will be exactly repeated.

Simple Color Studies

These color studies are in various stages of development, with different types of still-life objects. For learning purposes, it's best to choose a variety of objects and to paint under a wide range of lighting conditions. To keep your vision and your painting fresh, return to color studies throughout your development as a painter.

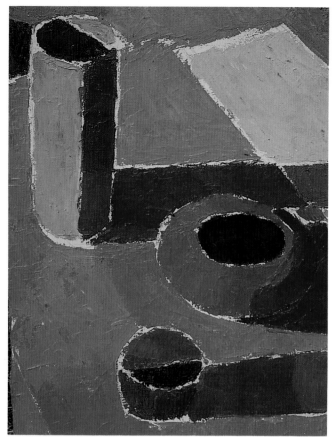

Study in Sun, Stephen Perkins, 16″×12″

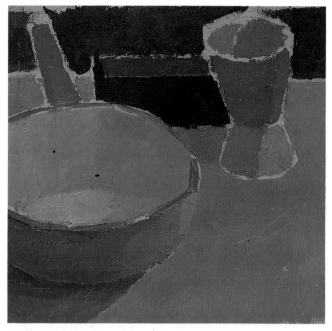

Still Life With White Pot, Stephen Perkins, 12″×14″

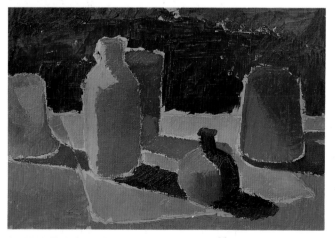

Still Life With Glass Objects, Susan Sarback, 12″×20″

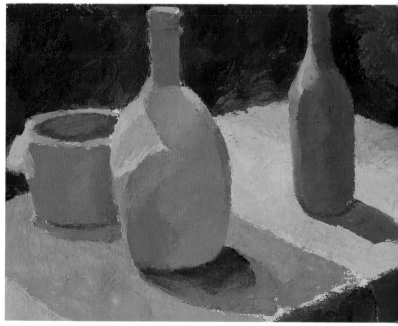

Sunny Day Bottles, Dale Axelrod, 12″×16″

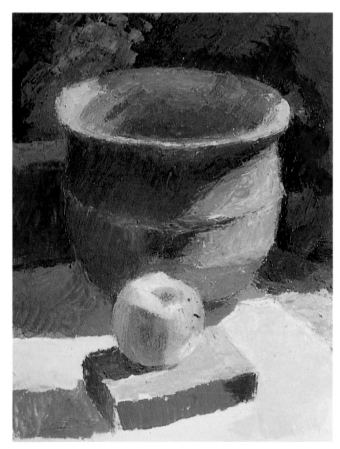

Sunlit Still Life, Ken Massey, 20″ × 16″

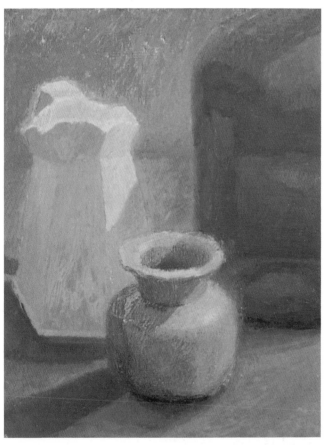

Summer Study, Susan Sarback, 14″ × 11″

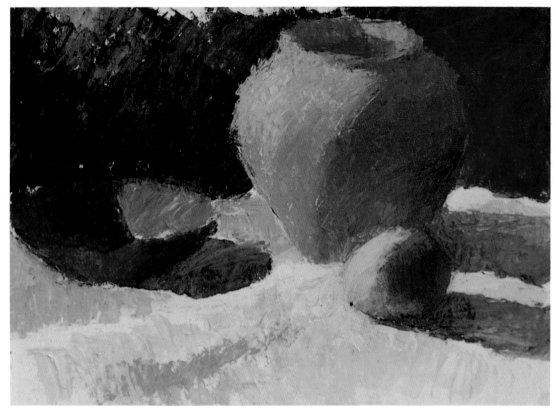

Study in Sun, Ken Massey, 12″ × 16″

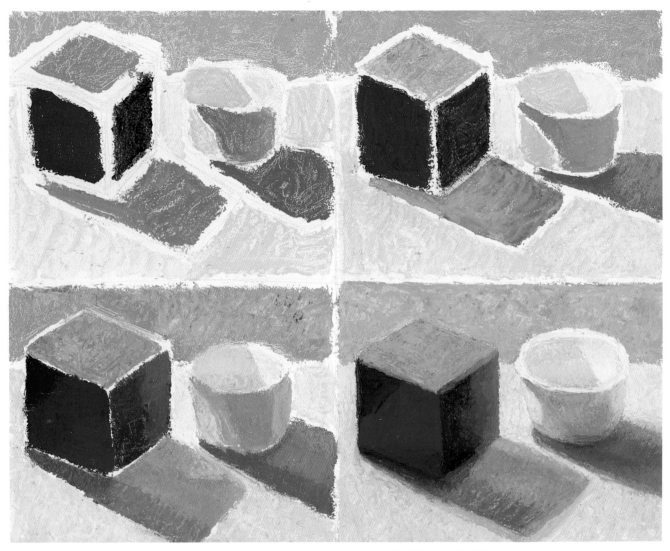

Block and Bowl Study, 20″ × 24″

The steps of this study show how rounded objects are developed in exactly the same way as blocks — starting with major color masses, refining the color mass statements and developing the color variations. In this way, the roundness of the object is created using color.

ROUNDED OBJECTS

From the basic study of blocks, students move into studies with rounded objects, such as cups, bottles or bowls, approaching them in the same manner as the blocks. See the objects in a few main masses, looking for the color-and-shape patterns that are created as the light falls across the form. Every color note has a specific shape; don't just paint in dabs of color. Instead of using value differences such as shading and highlights to create roundness, simply observe the color patterns that naturally make the object appear round. No matter how complex the subject matter, the basic process of seeing and painting is the same.

FLAT PLANES

Color changes do not occur only on three-dimensional forms. You will eventually see color changes on a plane as it recedes (a recessional plane) and on a plane from side to side (a horizontal plane). These are usually more difficult divisions to see, but with practice, the changes that are there will become more obvious. For example, a tablecloth in a still life would have both these kinds of color changes, horizontal and recessional. One side of a pink cloth may be slightly more orange than the other, and the back of the cloth may be slightly cooler than the front.

Often, recessional colors will be easier to see with distance or under certain weather conditions. A short, recessional plane, like that of a tablecloth, often has subtler changes than the longer recessional plane of a meadow.

Still Life With Chinese Figure, Stephen Perkins, 16″ × 12″
In these initial color statements, the artist saw and painted the changes in color from fore-ground to background on the tabletop. There are three distinct areas of color. These are color variations in the major mass of the tabletop, and they make the tabletop recede.

(Below)

Hazy Summer Evening, Peter Guest, 12″ × 24″
Bands of colors create the impression that the field is going back in space. The artist saw several color variations in the field. The color of the meadow in the background where it meets the trees is a different color from that of the meadow in the foreground, even though the local color was the same.

Seeing and Painting Color Variations

This outdoor still life includes a variety of colored and textured rounded objects. I placed them with the sun coming from behind in dappled light from an overhanging tree. As with all my paintings, I worked directly from life. I worked on this painting for a few weeks, paying special attention to the color variations within the major masses.

Color variations are subdivisons of color seen within a color mass. As these color variations are painted, the form and detail of the subject emerge. This is especially obvious when painting round objects.

In tonal-value painting, shading and highlighting are used to create form and roundness. With full-color seeing and painting, roundness is formed by a pattern of colors and shapes. The light falling over objects creates these ordered, observable patterns. These are the patterns of color that we see and paint when we paint the color variations of a mass. When painting variations, remember that every color change is a shape change. See your variations as distinct shapes.

Color variations can be used to help create the focus of a painting. The eye is drawn to the areas of greatest color development. In this painting, the background has less color development so it will not compete with the candle.

Here's a photo I took of a still-life setup of three rounded objects. I chose objects of varying sizes, colors and surfaces to provide variety. This study was painted in early summer in the midmorning on clear, sunny days. I worked on it about a dozen times.

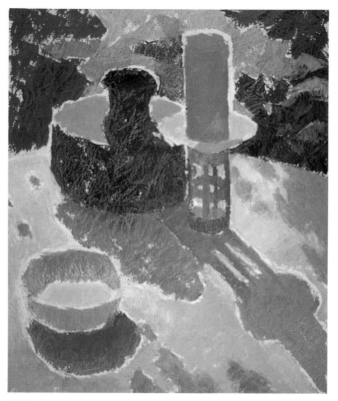

STEP 1. After my initial sketch, I laid in the major color masses on my gessoed Masonite board. It's a good idea to make every mass a different color, to help you differentiate between the masses. As your vision improves, you will notice that colors that used to look the same as each other now appear as distinct colors.

STEP 2. In this step, I refined the masses and began to paint basic variations of color within each mass. I made sure to maintain a clear distinction between the light plane and the shadow plane to keep the effect of bright sun. I scanned and compared to see what colors were needed to improve my initial statements. Among other changes, I changed the tabletop from pure yellow to orange-yellow in upper left, and I added some yellow to the inside of the white bowl.

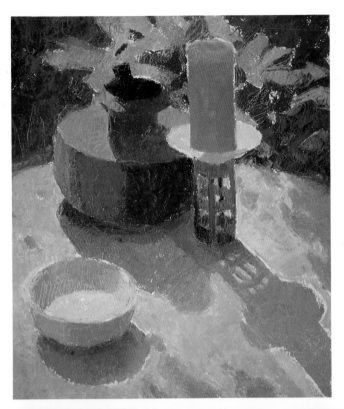

STEP 3. In this step, I saw more variations in the masses. I began to see hints of coolness in the light planes. Light planes are generally warmer than shadow planes, but this does not mean the light planes have only warm colors in them. I saw a bluish cast to the light plane on the shoulder of the pot. The inside lip of the candle holder is in full sun but is a cool bluish pink color. I saw the inside of the white bowl as less warm and pink, so I made it cooler by adding a little blue-green.

By the same token, shadow notes are not always cool colors, even though they tend to be cooler than the light planes. Full-color seeing helps me see the warmth in the shadows. I added warm colors to the cast shadows of the pot and the white bowl, making one reddish and the other more magenta.

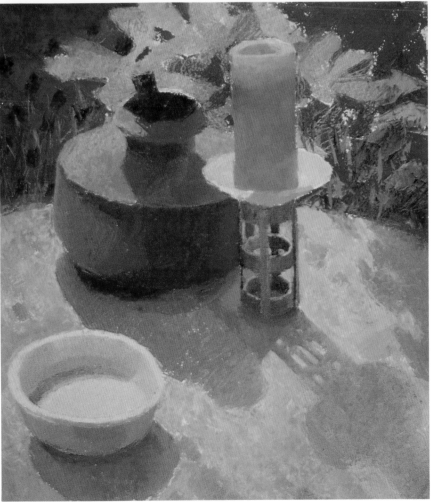

PAINTING A SIMPLE COLOR STUDY

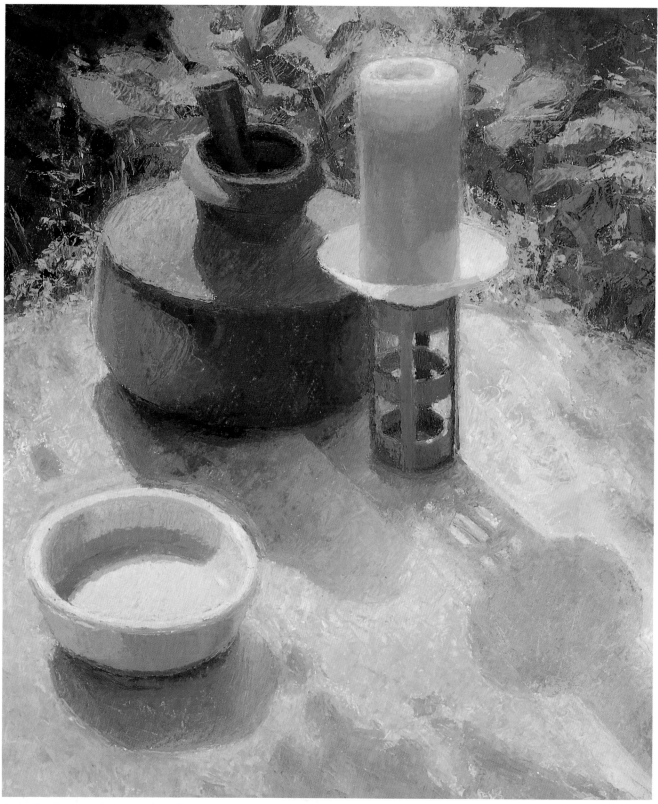

Sunlit Candle, Susan Sarback, 24″ × 20″

In this step, the area of focus, the candle, is further developed by seeing more color variations. Notice also how the background was developed. Initially, I saw it as simple masses, and then I worked into the more complex patterns of light and color. I didn't focus on each leaf, I looked for overall patterns of light and color. I didn't want the viewer's attention attracted to that area, so I painted fewer color variations there.

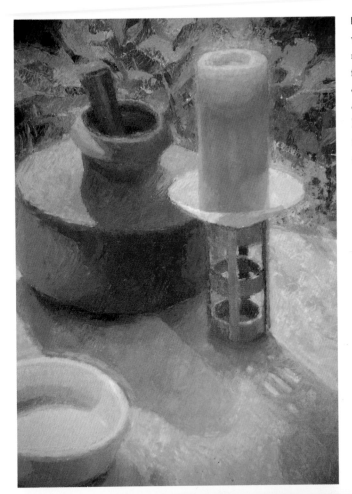

DETAIL. This detail highlights the many variations seen in the candle. I made the most refinements in this section, because it was the focal point of the painting. The translucent candle in full sun created a glowing effect called a *halation*. To capture this effect, I looked for color changes between the edge of the candle and the background. Just above the candle I saw a pinkish color.

DETAIL. The cast shadows are not just neutral tones, they are specific colors. In this painting, the shadows of the bowl and the pot fall on a pink cloth and are both warmer than the shadow of the candle, which falls on a different surface. However, the shadow of the bowl is warmer and redder than the pot shadow, which is more violet. To see these specific shadow colors, I scan and compare.

PAINTING A SIMPLE COLOR STUDY

DEMONSTRATION
Seeing and Painting
Color in Shadows

Shadows often play a key role in the composition of a painting. This is especially true in this painting, where the objects are backlit, casting long shadows forward. The shadows of the three glass objects are just as important to the composition as the objects themselves. I created a complex pattern with the long leaf shadows at the top of the painting and the soft shadows from overhanging trees on the right.

Look to see the color of a shadow the same as if it were an object — see it as a mass of color. Look for the color differences between each of the shadow notes. The color of a shadow depends on a variety of factors — the color of the object, the color of the ground, the pervading light and so on. Scan and compare to accurately see the shadow color in relation to its surroundings. Shadows usually vary in color from the base to the center to the edges. Look for these differences as you paint the color variations.

This photo shows the setup — translucent glass objects in full sun. I don't paint from photos because they don't capture the color. I put the objects on the ground and looked down at them. I wanted a viewpoint that would show how full-color seeing can be used in a variety of subject matter or compositions.

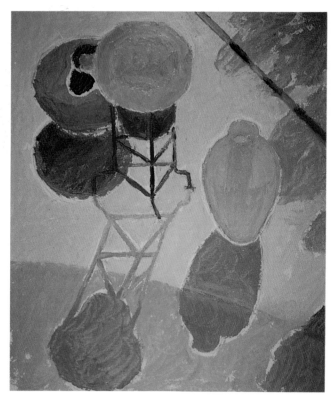

STEP 1. I began with the major masses, painting the blue bowl magenta, because the warmth in sunlight was more predominant than the local color. To help, I held up my hand to make a shadow on the bowl and then compared that color to the color of the bowl in sun.

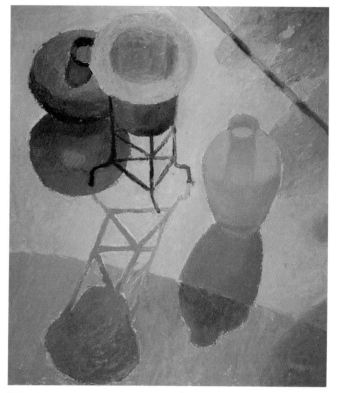

STEP 2. I added blue to the vase, leaving enough of the warmth underneath to show the sun. I also saw coolness on the top of the central green object but left warmth underneath. Notice the big change from blue to greenish in the shadow of the yellow pot.

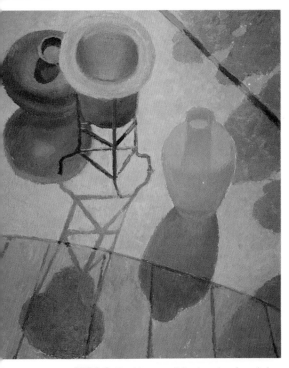

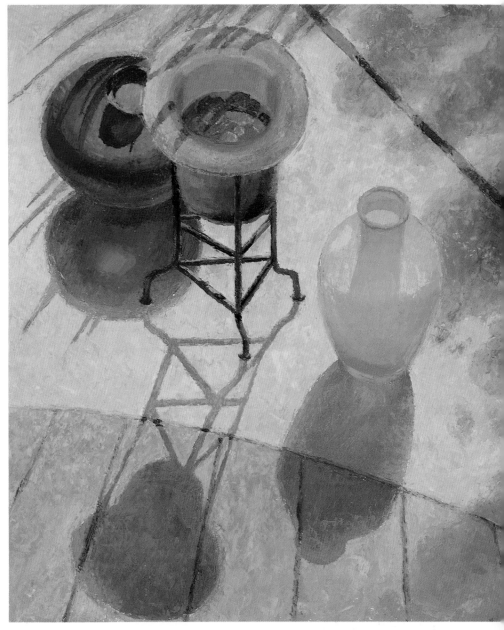

STEP 3. In this step, I further developed the variations in each of the masses. As a painting develops, I keep adding colors into each mass to make them more accurate. I don't try to mix the exact color I see; I add color to modify what's already on the canvas. For example, in this stage, I saw the cast shadow of the middle object as more blue-green than steps one and two. I didn't cover up my initial statements with a brand-new color. I simply added blue-green into what I already had. In this way, the masses develop into complex colors that don't really have names.

Glass in Sun, Susan Sarback, 24″ × 20″

Sometimes you can't foresee what a painting may need. When I got to this stage, I added the leaf shadows in the top left corner. I created the shadows by placing a vase with leaves behind my setup so I wouldn't have to make up the colors. I also added some water to the blue-green bowl and floated some leaves in it to create an interest point. The cast shadows on the upper right are from trees and are softer than the object shadows. The edges are not as sharp, and the colors are not as deep.

Comparing Sunny and Cloudy Days

In the middle of painting the sunny-day painting of the glass objects, it was cloudy for a few days, so I did a cloudy-day version of two of my still-life objects. I saw the colors of the masses as richer and cooler than I had seen them on the sunny day. The blue pot has less warmth on the cloudy day, and the yellow bottle is less orange. Yet the colors are not gray; they are actually very saturated and vibrant. Comparing sunny and cloudy helped me see the warmth and intensity of the sunny-day painting when I returned to it.

STEP 1. The initial masses in this cloudy-day study are more somber than on a sunny day. There is less warmth and intensity, yet I could still see the full spectrum of color.

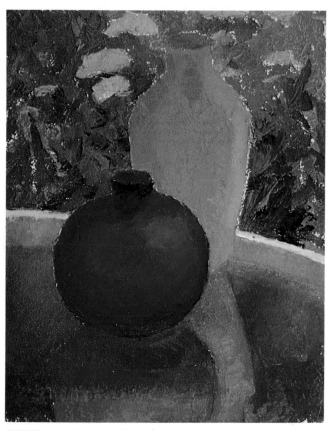

STEP 2. I continued to refine the masses and then see variations. Notice the reflections in the frosted glass tabletop. I painted all surfaces—reflective, opaque, transparent—in the same manner, by seeing color masses and variations within the mass.

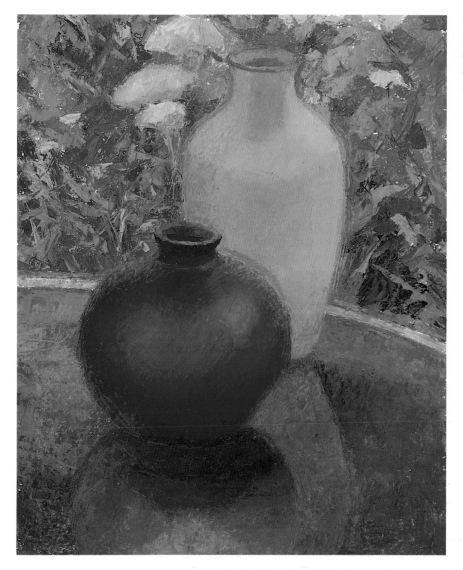

Cloudy Day Glass, Susan Sarback, 14″ × 11″
Notice the warm, magenta light coming over the edges of the blue vase. This was a special quality of the light falling over the translucent vase.

TIPS

For Painting With Full-Color Seeing

1. Start with clean, strong colors; don't refine too fast.
2. Don't overanalyze. If you think too much, the painting often looks labored and overworked.
3. Compare color notes to each other, even ones outside of your subject.
4. Notice large patterns of light and shadow in the entire painting.
5. Think in terms of color next to color, not object next to object.
6. Keep scanning. Don't look directly into a color. If you look directly at a color for too long, you will begin to see its complement, and the color will appear duller.
7. Make the major color masses different from each other.
8. Mix colors right on the canvas by adding color into the mass.
9. Make variations in a mass distinct. They should be as accurate as the mass itself.
10. Don't paint only the colors you like — paint the colors you see.

The Rose Trellis, Susan Sarback, 14″×11″

CHAPTER FOUR

SEEING COLOR RELATIONSHIPS

Basic order is underlying all life. . . . To study art is to study order,
relative values, to get at the fundamental constructive principles.
It is the great study of the inside, not the outside of nature.

ROBERT HENRI

The subject doesn't matter. One instant, one aspect of nature
is all that is needed. . . . Nature is a most discerning guide,
if one submits oneself completely to it.

CLAUDE MONET

Beauty in art is the delicious notes of color one against the other.
It is just as fine as music, and it is just the same thing,
one tone in relation to another tone. . . .
There are just so many tones in music and just so many colors,
but it's the beautiful combination that makes a masterpiece.

CHARLES HAWTHORNE

Beauty—the adjustment of all parts proportionately so that one
cannot add or subtract or change without impairing
the harmony of the whole.

LEON BATTISTA ALBERTI

It is only through the sense of right relation
that freedom can be obtained.

ROBERT HENRI

Seeing color accurately is not unlike seeing form accurately; everything must be seen in relationship. I remember watching a beginning art student work on a charcoal portrait of a model. He labored intensely on each facial feature, making sure to closely observe the eyes, nose and mouth. But when he finally took a break and stepped back, he saw that his portrait was all wrong; the eyes were too far apart, the nose was too big for the face, and the mouth was too close to the nose. Because he had focused on each part without relating it to the whole and to the other parts, he missed the likeness of his model.

All of the parts must relate to capture the effect of nature. The same principle applies to capturing the effects of light. Through accurate color relationships, the light begins to emerge in a painting.

Wooden Pony, Susan Sarback, 12″ × 16″, collection of Evelyn Harlan
I find single-object paintings such as this especially challenging, because there's no complex subject matter to create interest. The interest arises only out of the color relationships.

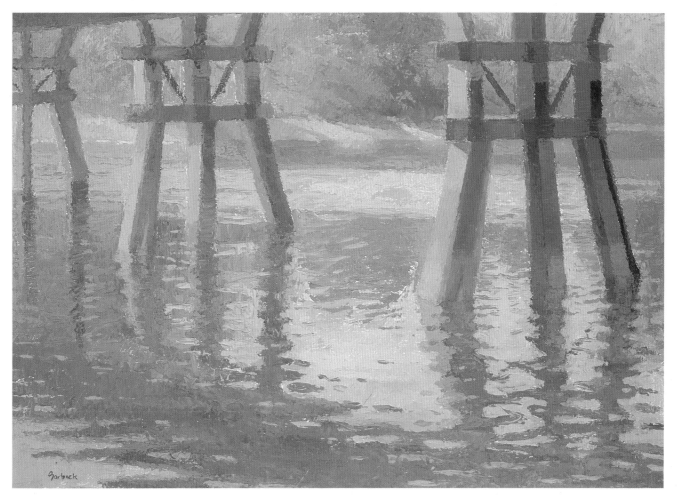

Rippling Breeze, Susan Sarback, 18″ × 24″

I did this painting on a late summer morning of the pilings of a footbridge across the river near my house. The local color of the pilings was dark brown, and the water was a muddy color. I had to scan and compare to see the colors beyond the local color. I saw that the water changed from a deep, warm, orangish color in the front to a cooler purplish color in the back left.

BEAUTY IN COLOR RELATIONSHIPS

One winter morning, I was painting an indoor still life of a wooden pony near a window. The painting was about two-thirds completed, but it was dull. I tried to improve it, but I knew only tricks and gimmicks, like using "prettier" color or creating an aura of lighter colors. Nothing worked. Finally, I put my attention back on the color relationships I saw. That's when the painting became radiant.

I used to expect that my best paintings would be the ones I'd worked on the most, the ones with the most finishing touches and carefully observed details. A quick study I did as a beginning student proved me wrong. It was only 9 × 12 inches—a small, hazy sunrise painting of a Provincetown lane, which I completed in one session. In a few large color patches, I simply indicated the main color relationships I saw. I didn't paint any details. The light changed quickly as the sun rose, so there was no time for lengthy development. It was only later that I saw the special quality of this little painting, a freshness and vitality that still cause comment from visitors to my studio. Its beauty rests solely on the main color relationships.

Full-color seeing is the study of light as revealed through color relationships. A painting is made up of patches of color, or *color notes*. Each is a part of the whole picture. We see a true color by relating each note to the whole painting and each note to other notes.

The principles of full-color seeing are essential to seeing these color relationships. You need to be relaxed and receptive. Looking directly into a color, or mentally prejudging colors yields mainly local color or a neutral effect.

Seeing color relationships means learning to relate parts to parts and parts to the whole.

COMPARING PARTS TO PARTS

When a painter paints a portrait, the eyes must make sense within the context of the whole head. But they must also relate properly to the nose, the mouth, the ears and the chin. Each part must relate not only to the whole, but also to all the other parts. The same principle applies to seeing color.

Comparing a color note to other color notes, both next to and farther away on the painting, helps you see color relationships. Try asking the questions:

- Which one is brighter or deeper?
- Which one is warmer or cooler?
- Which one is more vivid or dull?
- To what specific color direction is the color note leaning? Toward blue? Red? Green?

I may see that a shadow is cooler and deeper than the light plane. By scanning and comparing the shadow note to other notes, another shadow, a surface in half-light, or something in the far distance, I gather information about the color note I'm working on. It may be a subtle, composite color, but I can determine the specific color it is leaning toward, perhaps a blue, green or violet.

Some relationships will be easier to see than others. It's easier to see the obvious difference between two notes that contrast each other, such as violet and orange, than a subtle difference between two similar color notes, such as violet and blue. Suppose I am painting two apples in sunlight casting shadows on a blue cloth. It would be easier to see the color difference between the light and shadow sides of the apples than the color difference of the two cast shadows on the blue cloth.

Once I do see the subtle difference between these two notes (perhaps one shadow is bluer, the other more violet), I paint it so the distinction is evident. Often color observations must be painted more obviously than one might imagine, in order for the distinction to be available and clear.

Blue Fan and Tulips, M. Manegold-Wanner, 23″×28″
In this painting, the local color of all the tulips was the same pure yellow. The artist had to compare the tulips in direct light to the tulips in shadow to see the color differences between them. The fan also changes color, not just value, as it moves from shadow into light.

North Light Still Life, Hilda Neily, 16″×20″
The local color of the three main objects in this study is fairly similar. The artist had to compare each to the others to see the back bottle as more orange, the pitcher as pinker, and the bowl as more yellow. Each object subtly leans in a certain color direction; it doesn't have to be overstated.

COMPARING PARTS TO THE WHOLE

Suppose I am painting a landscape with a bush in sunlight and a fence in shadow. To see the color note for the bush, I scan the scene, noticing how the bush note relates to the whole scene. I sometimes use questions to guide my vision. Is the bush the brightest spot in my view? The deepest? The warmest? The coolest? Of course, most of the color notes in a painting will fall somewhere in the middle of these ranges.

After I scan the scene, I look at my painting. I may notice that the actual bush seems to stand out with its warmth and brightness, whereas the bush in my painting seems to blend into the fence in the background. My first impulse may be to change the color of the bush. However, since the light effect is a result of the interrelationship of all the color notes, I also need to check other color notes. It may be that the color of the bush is fine, but the shadow note of the fence needs be modified — made cooler or less neutral. This can only be determined by scanning and making repeated comparisons. With practice, it becomes a habit to see color relationships; it feels more natural and less analytical.

One way to gain perspective on the whole is to look entirely outside the view you are painting. By comparing dark notes to a black object, such as the handle of a painting knife, it is often easier to gauge the correct degree of depth and color. Similarly, light notes can be compared to a pure white object.

This technique of looking outside the scene being painted can also be applied to seeing specific hues of color. If I'm painting a still life with a shadow note that looks blue, I may compare it to the bright blue sky overhead. I often advise students to look away from their still-life setups as an aid to seeing color.

Late Afternoon, Susan Sarback, 14″ × 11″
In this quick study, the bush in sunlight was the brightest, yellowest part of the painting. To make it stand out, I compared it to the color of the fence, the background bushes, and the shadow note of the bush. Every time I changed a color on the fence or shadow, I had to check the whole painting to see if the relative brightness of the yellow was still intact.

Ivy by the Window, Peter Guest, 20″ × 16″, collection of Dezie Lerner
In this scene, the background is in a soft winter light, and most of the foreground is backlit and in shadow. All of the color notes of the background had to be checked against the whole, to make sure they stayed back. Likewise, all of the color notes of the objects had to be checked to make sure they stayed forward.

Comparing Color Notes. A common mistake is to stare directly into shadows trying to see the color. This makes shadows seem deeper than they really are. Try to compare the shadow to other dark areas, outside of your subject — a black object, such as the handle of a black painting knife. Place it in the shadow area. This helps show that the shadow is an actual color, not just dark gray.

REFINING COLOR RELATIONSHIPS

Students sometimes labor exclusively on an individual color note, or on a specific area of a painting, trying to get it exactly correct before moving on to another area. But accurate color relationships do not result from a single-minded focus on getting it right the first time; they emerge out of a process of continual refinement.

Let's take the example of a student working on the color note of the cast shadow of a backlit white vase on an orange cloth. The shadow is an indeterminate bluish violet color. The student paints it first blue, then more purplish, then adds green, then blue, but nothing seems right. Finally, she turns her attention to the adjacent color notes of the vase and the drop cloth, adjusting each slightly as she rescans her setup. The vase needs a bit of blue, and she adds yellow and orange to the cloth. Suddenly the shadow note looks better! No matter how long she labored over it, she couldn't improve the shadow until she addressed other notes on the painting.

A painting is developed as a whole, not section by section. Each color change will have an impact on all the other colors in the painting. Sometimes these effects are imperceptible, sometimes evident, requiring modifications in other notes. In this way, the color relationships are slowly refined, and the painting develops as an organic whole.

We begin by stating the obvious and then move toward subtlety. Initial boldness and vigor lend strength to a painting as the color relationships are developed and refined.

Refining Color Masses. These quick color sketches show how to refine initial color masses. This was a white vase backlit in shadow on an orange cloth. The three vases on the left are all the same — the first step of initial color masses. The three on the right are three different ways that these initial statements might be modified.

The top version is an accurate second stage — the vase has been modified to show the warm light reflecting up from the yellow cloth.

The middle version shows the result of staring into the vase instead of scanning to see the color — the reflected light is overstated, too yellow and bright. This takes the vase out of shadow and makes it look like direct sunlight, a common problem when painting reflected light.

The third version shows the background painted too light and too pink, missing the depth of color. As a result, the vase blends into the background.

A VISUAL APPROACH TO PAINTING

The painting that flows out of full-color seeing is based on
the artist's visual perceptions, but along with the refine-
ment of color vision, the skill to express these perceptions
in paint must be developed. Very often, the painter's vision
is a step or two ahead of his ability with pigment.

I remember as a beginning student painting a white
house. One side was dappled with shadows from a large
tree. I was excited when I saw that the shadows were not
gray, but a blue color, but I had to struggle and experiment
to find the right combination of pigments to match my vi-
sion. Over time, though, choosing such colors becomes less
of a struggle.

Summer Afternoon, Hilda Neily, 20″ × 16″
This painting shows how full-color seeing uses color rather than drawing
to create form and light. The artist didn't draw shutters and fill them in
with the local color. She saw them as color variations within a larger
mass, and out of this, a recognizable image emerges.

DEMONSTRATION
Using Color to Create
Light and Build Form

I chose this garden scene because it had the clearly defined form of the statue and the looser shapes of the plants and flowers. I wanted to show how a variety of forms can be described with light and color.

Color both builds form and creates light. Some artists paint solid forms illuminated by a clear source of light, others are interested in dissolving form with light and atmosphere. With full-color seeing you can paint sharp, precise forms, loose atmospheric scenes, or anything in between.

Full-color seeing and painting builds form with masses of color. Instead of describing form with lines and values, forms are built through color variations. This approach differs markedly from tonal painting, in which color is added on to a value drawing. With full-color seeing, color is a key element from the very first step.

In full-color seeing, color also creates light. By contrast, in tonal painting, value contrast creates a sense of light.

This photo shows my subject—a statue in a garden on a sunny day. The local color of the statue was pale gray, and it was nearly life-size. I liked the strong light-and-shadow patterns on the statue and the surrounding flowers and trees.

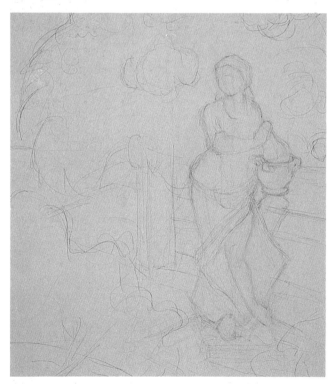

STEP 1. Working from life, I drew a quick pencil sketch onto my 24″ × 20″ gessoed Masonite board. I indicated the basic proportions of the statue and the general masses of the background. I was not concerned with details at this stage.

STEP 2. Next, I used a brush to indicate the major color masses, employing a different color for each mass. I noted which masses were in the light plane, which were in the shadow plane, which were cool and which were warm.

STEP 3. With a palette knife, I modified each mass to more accurately reflect the colors I was seeing. For example, the blue on the statue became brighter, the orange on the ground became deeper, and the magenta note behind the statue was painted cooler and deeper.

STEP 4. By seeing and painting the variations within each mass, I brought about the beginning of the shape of the form. Variations within a mass must always hold within the form. For example, even though the figure has purple and green variations in the shadows, it reads as a statue.

STEP 5. Here, more variations were painted within certain masses. The statue has more green variations in the shadow side; the foreground bush has more violets, reds, blues and greens; and the background bush has more warm accents.

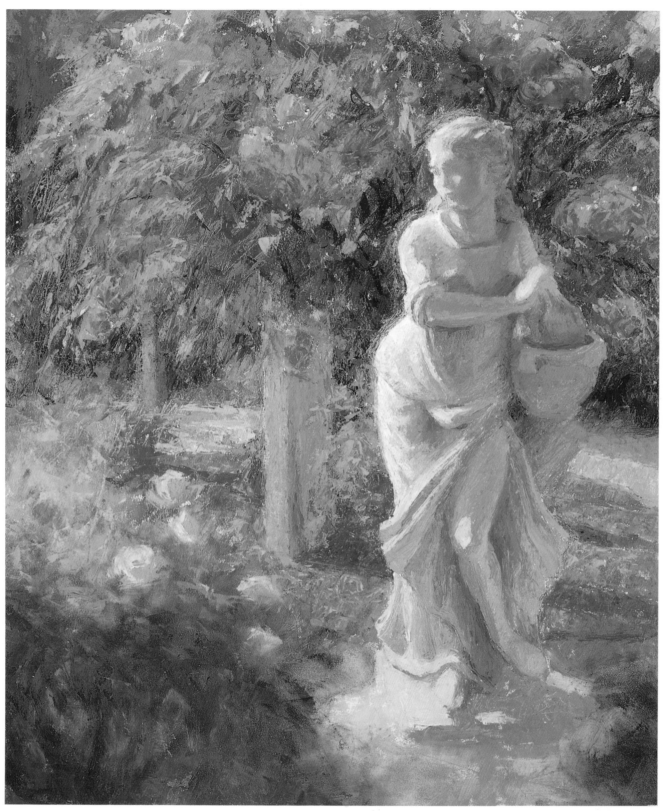

Statue in a Rose Garden, Susan Sarback, 24″ × 20″

In the final stage, I indicated facial features on the statue by developing smaller color variations. I painted more variations in the head and upper body than in the lower half of the figure to keep the focus on the face.

DETAIL. This is a detailed view of the statue as it is beginning to show simple color variations. Note the blues, purples and green notes in the shadow areas.

DETAIL. Now the statue has further developed color variations with more distinct violets, purples, greens and blues. The form is beginning to emerge, although detailed features are not yet indicated.

DETAIL. This detail shows the statue in its final stages. The variations are more apparent, especially in the light planes and the features of the face. You can see how these smaller variations create the likeness and bring the image into focus.

TIPS

For Seeing Color Relationships

1. Scan and compare.
2. Compare each color note to other color notes.
3. Compare each color note to the whole painting.
4. Compare color notes to colors outside your painting.

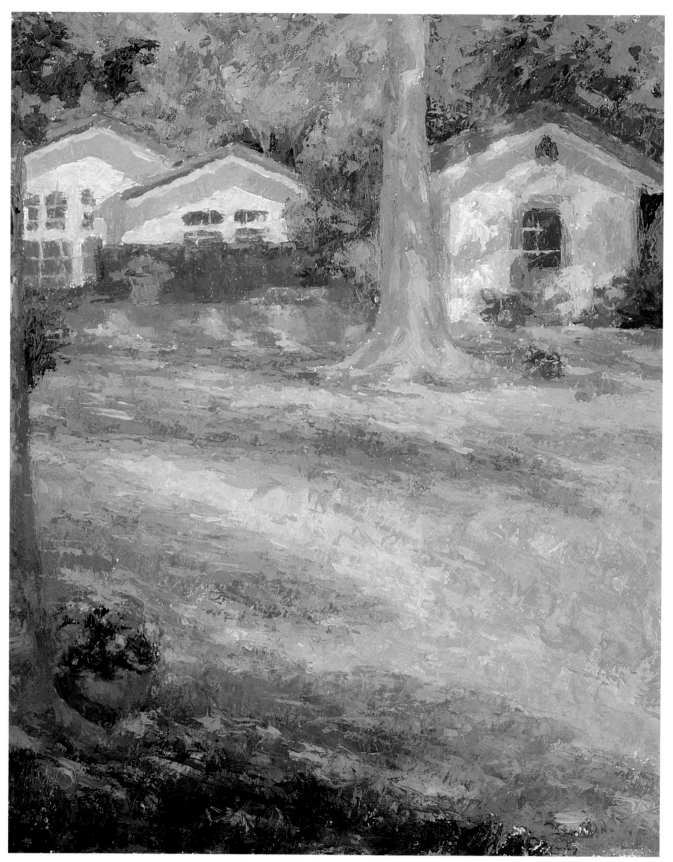

Summer Adobe, Susan Sarback, 20″ × 16″

CHAPTER FIVE

USING FULL-COLOR SEEING WITH ANY SUBJECT

It is not the language of painters but the language of nature to which
one ought to listen. . . . I think a painter is happy because he is in
harmony with nature as soon as he can express a little of what he
sees. . . . The greatest, most powerful imaginations have at the same
time made things directly from nature which strike one dumb.

VINCENT VAN GOGH

Think of color instead of sand—think of color instead of clothes—
color first and house after, not house first and color after.

CHARLES HAWTHORNE

Let color make form—do not make form and color it.

CHARLES HAWTHORNE

It is amusing how little one needs features for likeness—
think of color notes; spots, not planes,
when doing the face out of doors.

CHARLES HAWTHORNE

I remember painting a river scene as a beginning painter. It was a beautiful view and I was very inspired, but it was too difficult for me. I became frustrated and wanted to give up; it seemed too hard. From that experience, I learned to let myself grow step by step. As my vision and skill developed, I gained confidence with increasingly challenging subject matter.

Advanced painters eventually choose complex subject matter, including challenging surfaces to paint, such as water, glass or dappled patterns of light and shade, and advanced subjects, such as interiors, landscapes and the human figure. Yet, regardless of subject matter, all painting with full color rests on same foundations—the color relationships of the masses.

Full-color seeing can be applied to any subject; the principles are the same. No matter the subject chosen, see color first, not form.

Hazy Morning With Roses
Stephen Craighead, 36″ × 36″
Dense vegetation, patterns of shadow and light, flower, foliage and the distant house combine to make the subject of this painting more complex than a basic study. The forms are not simple, yet they are approached in the same way as the simple studies. The beauty rests in the relationship of the big masses and in correct variations. Seeing and painting these color relationships gives the painting its hazy, atmospheric quality.

LANDSCAPE PAINTING

Start with simple landscapes, perhaps a bush next to a house. Then apply the experience gained from doing simple studies. Houses are like blocks, bushes are like inverted bowls, and the ground is like the recessional plane of a tabletop.

As always, begin with the major masses, avoiding such details as doorknobs, trellises, berries on the bush, and so on. If the bush is half in shadow and half in light, paint it in two basic colors to begin with, as if it were a bowl, without detailing specific leaves or branches. The house can be painted just as a block would be. As you see the variations within each mass and fine-tune the color relationships, the bush will become more bushlike, and the house will become more houselike.

When moving on to more complex landscapes, it is still best to begin with a simple structure of major color masses. This will make it easier to paint more complicated forms like trees and water without getting lost in the details.

Shady Path, Hilda Neily, 20″ × 16″

This is an example of a landscape with architectural forms. For beginning landscapes, it's a good idea to incorporate some man-made elements at first. This is an easy way to lend structure to a scene with foliage and natural forms.

Noe Valley, Camille Przewodek, 12″ × 16″

This landscape shows how block studies are a foundation for landscapes. The sides of the houses are like blocks and the bushes are seen as simple forms, without details. The emphasis is on light-and-shadow patterns expressed in color.

DEMONSTRATION
Full-Color Seeing in Landscapes

Every landscape has its own particular character and feeling. For example, the arid northern California landscape in this scene creates a starker impression than the humidity and abundant foliage of the East Coast. In this painting, all of the trees had small, dense leaves of the same local color, a very dark green. The challenge was to see the change of color that distance and atmosphere created. I was also interested in the changes in the shadow colors as they fell across the grass onto the dirt path.

Landscapes have a sense of distance and atmosphere that still lifes usually don't have. Also, in landscapes, the local colors tend to be more earthy and natural. Look for the full spectrum of color within the range of local colors. Nature has both sweet and somber colors; the challenge is not to be overcolored, but not to be too neutral, either.

Organic forms, such as trees and clouds, are often more complex than man-made structures, such as houses or fences. Learn to simplify the mass of organic forms. You may need to edit elements — a tree may need an awkward limb left out, for example.

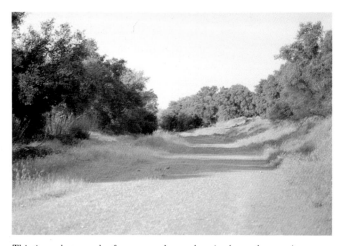

This is a photograph of a country lane taken in the early morning on a lightly hazy spring day. I chose it because it shows simple, clear shadow patterns and it has some distance.

STEP 1. This step shows my initial color statements — painted simply, without describing details. Notice the initial warmth seen in the sky and the bright yellow for the path. I make each color distinct to avoid generalizing colors. The cast shadows are similar, but each is a different color. On sunny days, it's good to start with bold statements to capture the shock of bright sunlight.

STEP 2. Notice the cool blue added to the sky. If I had started with blue, the sky would not have the feeling of a warm, sunny day. The large, green tree on the left in shadow might be expected to be a cool note, but I noticed that it had a warm, reddish color.

STEP 3. This shows the results of continued scanning, refining colors, and seeing and painting color variations. Sometimes a color note will be pushed back and forth in different directions before I find the right color. For example, the small bush in the front left started out bluish, became redder, and then moved back toward blue. There is no one right path to the correct color. Colors develop through repeated modifications.

STEP 4. I began to add deeper, cooler notes to the large tree mass on the left. To see the color of the distant trees on the right in sunlight, I compared them to trees in sunlight very near to me, which were not in the painting. This approach helped me to see the note as cooler than the near trees in sunlight, but still warm, since it was directly in the light plane.

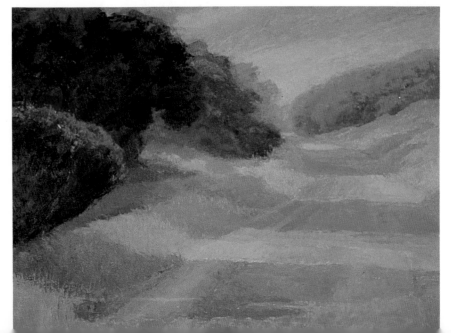

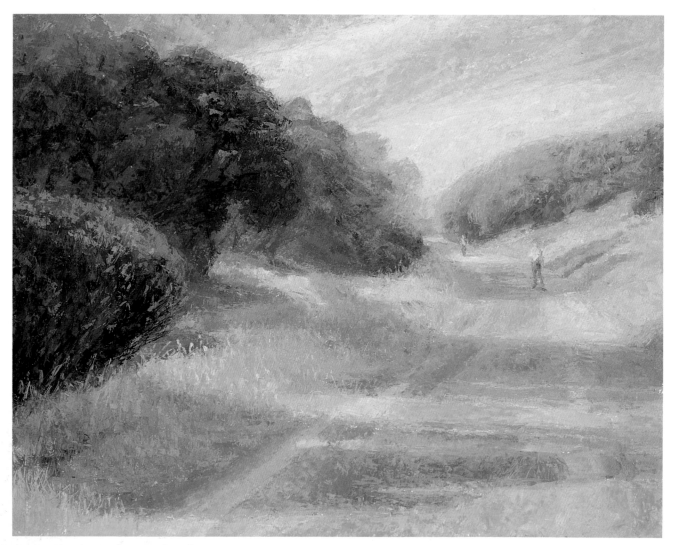

Morning Path, Susan Sarback, 20″ × 24″, collection of Terri Todd
Compare this to the initial color masses. The final painting has the feeling of sunlight, but it's not
as bold and shocking as step one. Start bold so that as you refine your colors, you won't lose the
intensity of sunlight.

DETAIL. When painting vegetation, the edges of forms may be less
defined. For example, the shadows falling on the tall grass have softer
edges than those on the road. Even so, the colors have specific shapes.

DETAIL. The figures, because they were in the distance, are seen as
simple color spots—not in terms of anatomy. In this way, they fit into
the landscape.

DEMONSTRATION
Landscape Studies

These are the initial stages of landscape paintings, in varying degrees of completion. Notice the big, simple masses without details. All of the completed landscapes in this chapter began in this fashion.

Morning Landscape, Stephen Craighead, 20″×24″

Mountain Landscape, Ken Massey, 12″×16″

Summer Study, Stephen Craighead, 12″×16″

Street Scene, John Ebersberger, 16″×18″

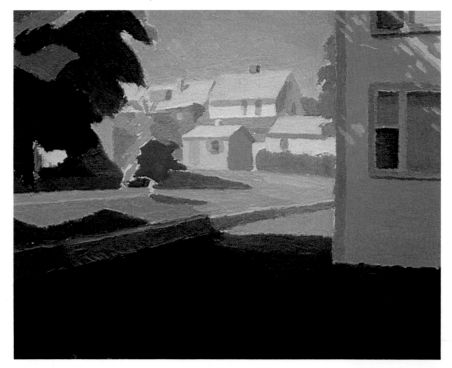

Afternoon Light, Stephen Perkins, 16″ × 20″

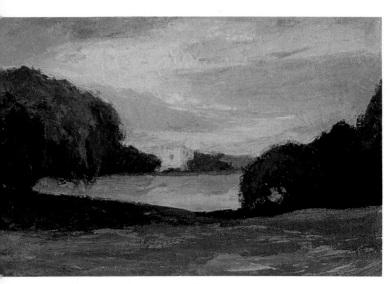

Stormy Day, Ken Massey, 12″ × 16″

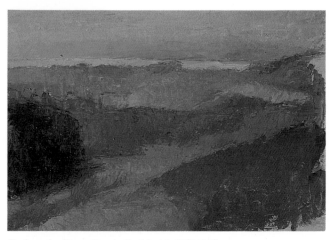

Dusk at the Shore, Steven Craighead, 12″ × 16″

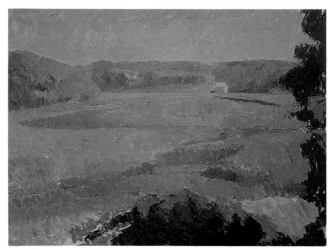

Landscape in Sun, Peter Guest, 18″ × 24″

DEMONSTRATION
Seeing and Painting
Patterns of Light

Your eye is led by patterns of light. The way to visually organize a complex scene is to notice the patterns of sunlight and shadow. Think of a subject as being patterns rather than the actual objects. People who see my paintings often respond more to the patterns of light and color than to the subject matter.

I chose this scene because of the bright, clear shapes and colors, and because it had a lot of visual activity. I liked the coolness of the scene, even though it was in full sunlight.

As I began painting, the surface of the pool appeared very complex. To simplify it, I looked to see what was in shadow and what was in light. I did the same with the walkway around the pool, the fence in the background, bushes and flowers. This way, I was able to focus my attention on painting the light rather than on describing objects.

After I saw the main areas of shadow and light in the pool, I looked for the reflections. Some of the reflections were in shadow and some in light. I saw them as patterns of color, not just value differences. The blue of the water in shadow was a cool color, but in the sun, it was a much warmer color. In this painting, I had to observe what was warm and cool in the water, but still make all the color notes read as part of the pool.

This photograph shows the pool in my backyard on a morning in late spring. I often paint scenes in my backyard, of the pool or garden. Since my real subject is the light, I don't feel the need to always paint majestic subjects.

STEP 1. I began with a 20″ × 24″ sketch on gessoed Masonite. Even though this is a complex subject, I simplified the scene into the major masses for my sketch, indicating the major areas of light and shadow.

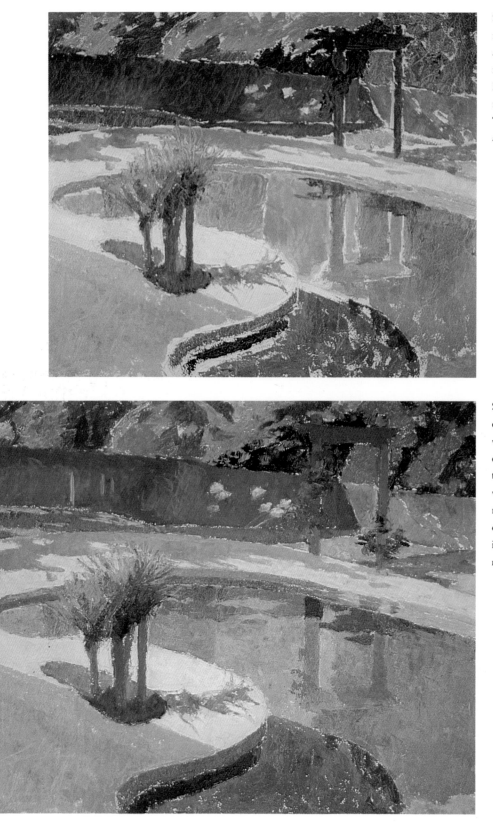

STEP 2. This step shows the initial color masses. Some are not obvious, such as the pink and blue-green colors of the pool. These are reflections of trees and sky; they are warm because they're in sunlight. The large, blue mass in the pool is a cool color and in shadow. The background has been simplified into light-and-shadow patterns.

STEP 3. This step shows the further development of the major color masses as well as some initial color variations. Because of the many forms, I spent extra time refining the major masses before I moved into the variations. Even in a complex scene, I don't rush into the details; they emerge out of the color variations. Notice that the sky reflection in the pool became cooler and the tree reflection became warmer.

STEP 4. At this stage, I began to paint more of the color variations within each mass, and the details began to emerge. The spikiness of the yucca plant, the flowers on the fence in the background, and the lines in the pavement all were seen as variations within larger masses. It's tempting to paint details first, to make your painting look "real," but the true strength of the painting rests on the relationship of the major color masses.

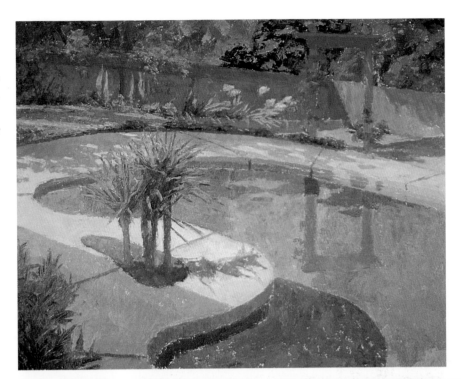

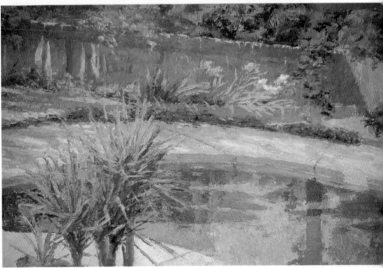

DETAIL. This section shows how details are created out of smaller and smaller color variations. The forms are not described with drawing but are built out of color. For example, the flowers in the background are painted as spots of color, yet they appear as flowers. I saw the spikes of the yucca plant as patterns of light and shadow.

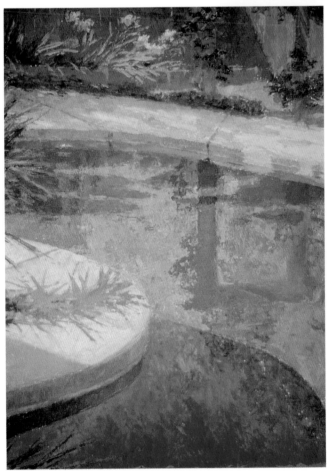

DETAIL. This is a close-up of the water showing reflections and cast shadows. The deep-blue shadows on the water on the upper left are from trees. The light-blue-and-pink area in the middle is the sky reflection. The lighter green area on the right is the reflection of trees in sunlight.

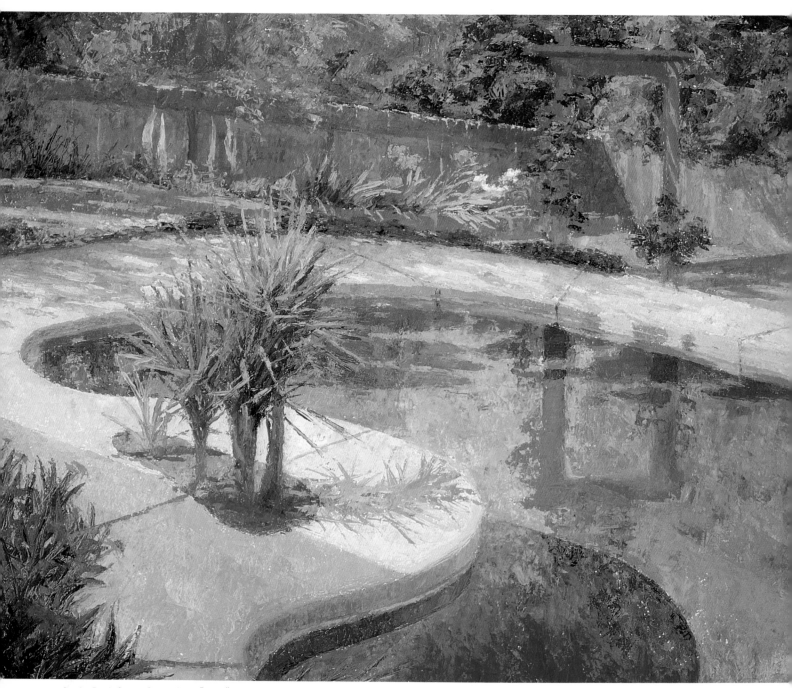

Sunlit Pool, Susan Sarback, 20″ × 24″

This stage shows the final refinements. I added more color variations in the reflection in the pool and in the background foliage. In some areas of a painting, I develop the color variations as much as I can; in others, I purposely leave them less developed. In this painting, I didn't develop the color variations in the background as much as I could have, because I wanted the focus of interest to be the pool.

DEMONSTRATION
Quick Landscape Paintings

All of these paintings were completed in one session, often in an hour or two. They show how full-color seeing and painting is based on the relationship of the major color masses. These paintings were done very quickly. Quick paintings of this kind are a great way to train yourself to see the scene in terms of light and color instead of literal subject matter.

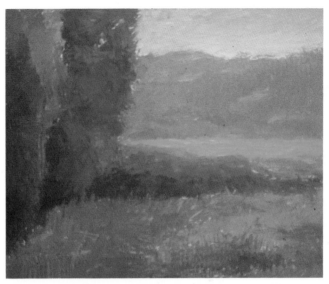

Late Afternoon, Stephen Craighead, 11″ × 14″

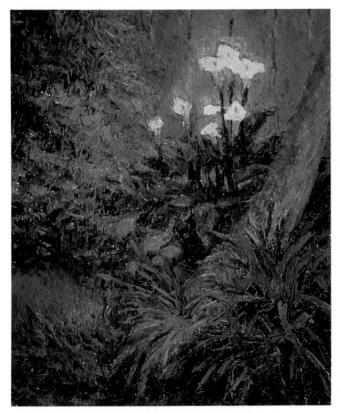

Cloudy Spring Morning, Susan Sarback, 14″ × 11″

Annapolis Sunrise #3, John Ebersberger, 8″ × 10″

Evening Fire Over the Catskills, Peter Guest, 8″ × 10″

Country Scene, Stephen Perkins, 8″×10″

The Back Door, Susan Sarback, 14″×11″

Dusk, Susan Sarback, 11″×14″

Hazy Afternoon, Dale Axelrod, 8″×10″

Fully Developed Landscapes

Following is a group of fully developed paintings by a variety of artists who have studied light and color. They show the range of subject matter that can be painted with full-color seeing.

Late Summer Afternoon, Peter Guest, 14″ × 16″
This painting was done in the countryside of upstate New York. It has a lot of warmth, even in the shadow areas, as it is mostly in sunlight. Notice the unusual yellow-green of the sky.

Wright's Beach Sunrise
Frank Gannon
12″ × 16″
This painting was done on the West Coast. It is a good example of recessional color changes creating a strong sense of atmosphere.

Hopkiln Vineyard, Frank Gannon, 20″ × 24″

This painting shows the intensity of California sun. It has less atmosphere than paintings by the ocean, or on the East Coast, where the air has more moisture. Notice the distinct shadow masses and the brightness and warmth of the light planes. These areas contrast with the somber, more subdued colors of the distant hills.

Morning Shadows, Chuck Ceraso, 20″ × 24″
This is a field scene painted in Colorado. Notice the variety of color in the foliage, especially the blues and violets in the cast shadows on the grass.

Lilies, Stephen Perkins, 30″ × 36″
collection of Northwood Institute
This painting is a careful study of variations
of color on the surface of a pond. Notice, for
example, how the color of the lily pads changes
as they move from sunlight into shadow, from
an ochre color to a deeper, greener color. Notice
also the subdued, warm colors of the distant
bank in full sun.

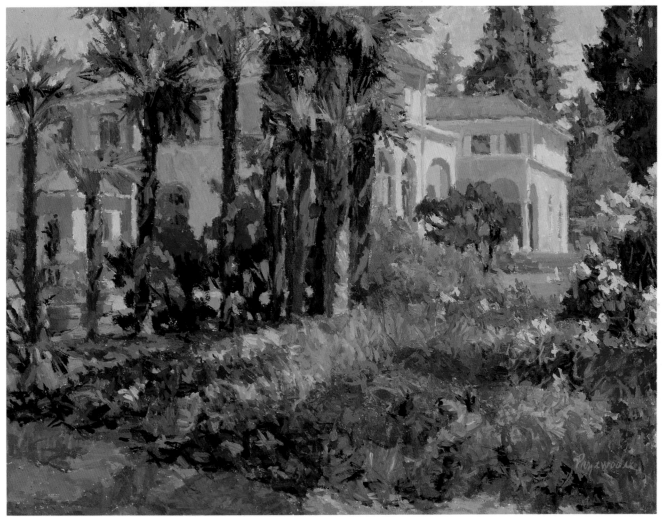

Picnic Grove, Camille Przewodek, 16″ × 20″
This is a bright California scene. The strong, clear colors create a vivid
sense of sunlight. The warmth of the sides of the house in shadow was
created by warm light reflecting up from the ground. The garden in the
foreground was loosely painted as patches of light and color yet reads as
flowers in sunlight.

PAINTING WATER

Painting water has its own unique challenges. Water, more than any other element, takes its color from its surroundings. A body of water, like an ocean, lake or pond, will be affected by the color of the sky as well as the surrounding land. As the weather, time of day, and season shift, so will the color of the water.

Water has reflections as well as shadows, often from several sources at once. In addition, the surface changes constantly with the wind. Yet, the process of painting water is the same as for simpler subjects.

Pool #6, Susan Sarback, 18″ × 21″
This is a simple composition with a difficult subject. I chose it to study the color blue in sun and shadow. I assumed that the water in shadow would be blue, but as I painted, I saw that it was actually more pink and violet. Notice how the reflections of the buildings and trees change color as they pass through shadow and light.

Pool #5, Susan Sarback, 17″ × 16″
In this painting, I studied reflections and cast shadows. The pool was in sunlight, as was the building being reflected in the pool. This created a lot of warmth on the pool, so I had to let go of any ideas about water being only cool colors. The deeper violet area was a shadow cast on the pool by a tree. Straightforward studies of water such as this one are a good foundation for painting the complexity of water in nature.

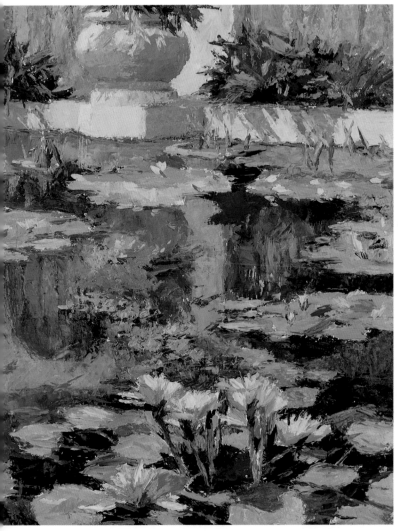

Balboa Park, Water Lilies, Camille Przewodek, 14″×11″
The complexity of this scene is from the reflections of the background
building, white urn and bushes, as well as the sky reflection combined
with the floating, sunlit lily pads. Notice that the water is a combination
of warm pinks and violets, and cool blues, blue-greens and purples.

Lily Pond in the Shade
Stephen Perkins, 20″×16″, collection of Dezie Lerner
A single ray of light breaks the shadows of this complex pond scene. The
artist observed the intricate color patterns of plants and rocks beneath a
still surface. Even though it's mostly in shadow and the colors are deep,
a full range of warm and cool colors was seen.

DEMONSTRATION
Using Light to Unify
a Complex Scene

STEP 1. This step shows my initial 20″×22″ sketch on my gessoed board. Because it was a complex composition, I spent more time than usual on my drawing. I had to establish the placement and shape of each object without getting lost in detail.

STEP 2. With my initial color statements, I established the main pattern of light and shadow. The sunlit view outdoors through the windows was simplified as a bright yellow mass. The indoor shadow areas were seen as deeper, and generally cooler, masses.

STEP 3. The outdoor yellow mass was cooled slightly, the left interior wall became deeper and greener; and the tabletop became warmer and richer and gained a color variation to show reflected light.

STEP 4. At this stage, I began to develop color variations in the masses. The tabletop is warmer and redder in some areas and cooler in others. The bushes outside the window began to take form as I added color variations. I also began to see variations in the glass vases and plate on the table. Don't be afraid to restate an entire mass at any stage of your painting. I added a lot of light green on top of the original pale purple to the back wall.

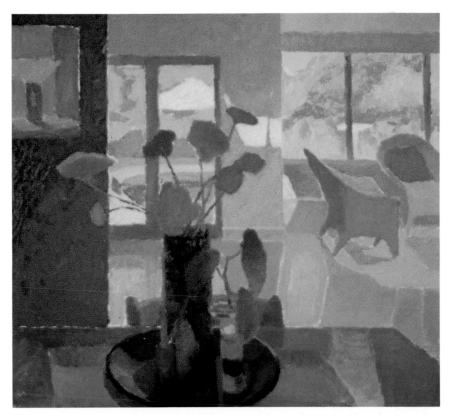

STEP 5. Further color variations begin to create the detailed forms. The reflections on the tabletop, the glass objects and the wooden floor all begin to look realistic as the variations are developed. The floor was one of the most difficult parts of the painting. I was continually tempted to make the blue reflections on the floor lighter and brighter, but when I compared them to the bright sunlight outdoors, I saw that they were actually rather cool and deep. I finally saw that the difference between the reflection and shadow on the floor was not so much a value contrast as it was a color change—the reflection was a cool blue, and the shadow was a warm, deep ochre.

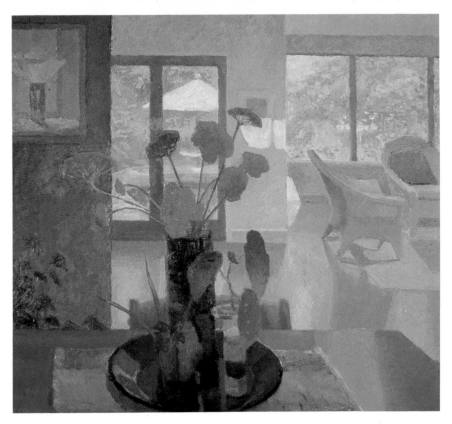

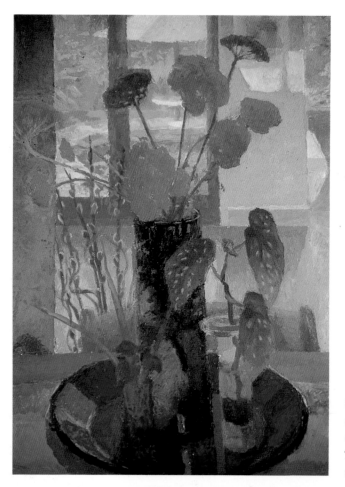

DETAIL. Full-color seeing and painting does not always mean pretty, pastel colors. The colors of the plate, vases and plants are deep and somber, yet full, rich. Full color exists in the deepest light keys as well as in the brightest. If your paintings start to consistently look too pretty or pale, do a few studies in deeper, more somber light. On the other hand, if your paintings look muddy, do some outdoor studies of brightly colored objects on a sunny day.

DETAIL. This detail shows how the interior objects are silhouetted against the sunlit outdoor background. The bright color and detailed color variations of the foliage pull the eye back through the painting. The interior objects have fewer variations and are seen as bigger, simpler masses.

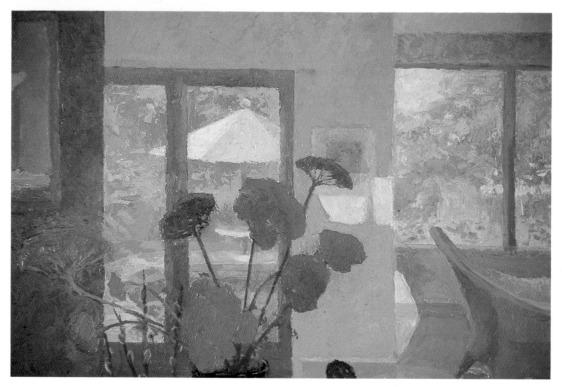

Inside on a Summer Morning, Susan Sarback, 20" × 22"

In this last step, I made some final refinements. The umbrella now has three distinct sides, all quite similar because all are in bright sun. I also developed the chairs in the background and the leaves in the foreground. As a painting nears completion, I often stop work on it for a day or two. When I return, I see it with a fresh vision, and I can easily spot the last few areas that need attention.

PORTRAIT PAINTING WITH FULL-COLOR SEEING

Portraits painted with full-color seeing have a unique sense of aliveness. The sense of light captured with full-color seeing lends a vitality and vibrancy to figures and portraits that is especially appealing.

To paint the figure using full-color seeing, use the same approach as with landscapes and still life; see the forms as a collection of color masses and work to refine the color relationships. When painting people, a knowledge of the figure will make this task easier. An understanding of form can help in painting subtle color changes, because it will be easier to see the specific shapes of each color. Developing strong drawing skills lessens the struggle with form when painting to capture a light effect with color.

The paintings here are portraits done in natural light based on the principles of full-color seeing. The figure is first painted in major color masses. The individual features rise out of variations of these major masses. Some are bold, simple indications of the figure, whereas others are highly refined and detailed.

Portrait on the Beach, Ingrid Egeli, 16″ × 12″

This study shows how the features of the head are seen as color masses. Notice the eyes are actually patches of violet paint, yet they easily read as eyes. The reddish color of the neck in shadow is clearly different from the purple of the shoulder in shadow. These simple color distinctions build the form and capture the light of a sunny day.

Farmer Figure, Dale Axelrod, 20″ × 14″

Instead of describing detailed features, this painting indicates the form through accurate color relationships. It shows how the essence of the figure can be captured with just a few color notes.

(Left)

Annie, John Ebersberger, 14″ × 11″

This is an outdoor portrait of a little girl on a sunny day. Notice the clear indications of light falling on the hair, face and shoulder. The shadow masses hold together, yet they are distinctly different colors — the hair has violets and oranges, the face is pinker and the sweater is blue-purple.

USING FULL-COLOR SEEING WITH ANY SUBJECT

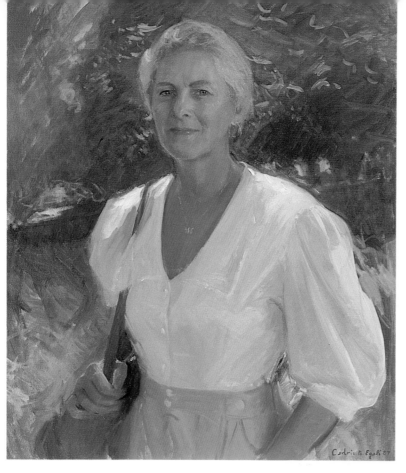

Mary Springer, Cedric Egeli, 28″ × 26″
This portrait was done on a summer day in the shade of a large tree. The color variations are most refined in the face and neck, whereas the clothing is painted with less detail. The background is simply indicated with notes of color.

Model in Yard, Ingrid Egeli, 14″ × 11″
Full-color seeing often yields unexpected colors, as shown in this outdoor study. The shoulder is blue; the neck contains greens, yellow-greens and magenta; and the forehead is a light lavender. However, all these colors relate to each other and to the whole, creating the image of a young woman outdoors.

Summer Portrait, Cedric Egeli, 16″ × 12″
This painting shows a backlit figure on the beach on a summer day. Notice the deep, rich color of the tanned skin against the light-filled background. The face has many subtle color variations that are completely in shadow. This silhouetted figure creates a strong impact.

Portrait of Amy, John Ebersberger, 27″ × 24″
The brightly colored parasol in this painting creates a soft, warm shadow on the figure. In this composition, the figure is part of the overall light-and-shadow pattern of the painting, rather than being an isolated center of focus. The artist has tied the figure to the background through light and color.

RADIANCE

Some paintings seem to glow, like sources of light. What causes one painting to appear dull, no matter how good the drawing or composition, and another to appear luminous?

Rembrandt achieved luminosity in his paintings through value differences — a contrast of darks and lights. Van Gogh created radiance using bright or complementary color combinations. Monet explored radiance by studying light. He created his paintings by seeing and painting the color relationships he found in nature. When color relationships are true, paintings sing with a radiance that echoes nature, regardless of subject matter.

Full-color seeing enables the painter to visually explore and refine color relationships, and thus to capture the radiance of light in paint. Before I discovered this way of seeing and painting, I tried other ways of making my paintings radiant — highly contrasting, intense complementary color schemes, vibrant color combinations or unusual lighting conditions. Full-color seeing and painting finally gave me a way to approach the radiance of nature; it can open all of us to the fleeting effects of light at a given moment — the light key of nature.

Park Lake Morning, Chuck Ceraso, 24″ × 30″

This painting captures the freshness of a summer morning. The pure, clear colors create a sense of the early light. The artist has seen both warm and cool notes within the major color masses of the bushes.

Sunned Sill, Susan Sarback, 14″ × 16″
The simplest of forms can be made radiant wih full-color seeing. There's no need for dramatic or complex subject matter to create interest. When light is the true subject, everything is interesting and radiant. Notice that the yellow object has different areas of peachy orange, ochre, bright orange, yellow-green, yellow and a pale blue green. The cast shadow has yellow, red orange, green, purple and blue. These color variations create the sense of light.

In the Rose Garden
Margaret E. McWethy, 20″ × 16″
The correct relationships of shadow notes to light notes creates the sense of sunlight in this painting. Notice the shadow side of the figurine has both warm and cool colors — subtle greens and violets as well as yellows and rosy purples. The artist's clear vision of these colors helped make this painting radiant.

Color Field, Susan Sarback, 20″ × 24″

SEEING THE MANY QUALITIES OF LIGHT

The further I go, the more I see how hard I must work to render what
I am trying for, that instantaneousness. Above all the outer surface, the
same light spread everywhere. . . . For me, the subject is insignificant.
What I wish to reproduce is what is between the subject and myself.

CLAUDE MONET

The "instantaneity" that he wanted was first of all a principle of
harmonious unity: the permeation of the entire scene
with an identical quality of light and color.
He was trying to stop time, not hurry it along.

WILLIAM SEITZ (about Monet)

If I could make musicians out of all of you,
you would benefit as painters.

JEAN-AUGUSTE-DOMINIQUE INGRES

If you have done your job well, anyone can tell if it is morning or
afternoon light by the color you use.

CHARLES HAWTHORNE

The Duc de Trévise, a French collector of paintings, reported this conversation he had with Monet: "Master, critics in the future . . . will be at an even greater loss to explain your famous 'series'; to make people understand that you composed entire collections of canvases on a single motif. Philosophers will claim that it is philosophy. . . ."

Monet replied, "Whereas it is honesty. When I started, I was just like the others; I thought two canvases were enough—one for a 'gray' day, one for a 'sunny' day. At that time, I was painting haystacks that had caught my eye; they formed a magnificent group, right near here. One day I noticed that the light had changed. I said to my daughter-in-law, 'Would you go back to the house, please, and bring me another canvas.' She brought it to me, but very soon the light had again changed. 'One more!' and 'One more still!' And I worked on each one only until I had achieved the effect I wanted; that's all. That's not very hard to understand."

Autumn in Massachusetts
Earnest Principato, 12″ × 18″
collection of Dezie Lerner
This painting is bathed in the warm light of late afternoon. The local color of the trees, the grass and the water are all different, but they are unified by the pervading light.

Monet demonstrated with masterful clarity how the lighting effect of a scene will move through many changes: changes based upon the time of day, the season, the weather, even the geography. Monet called the overall light condition of a scene "the envelope of light in which all things are contained." Charles Hawthorne, borrowing a term from music, used the phrase *light key* to describe the same thing. The light key is the overall light condition, affecting everything in view.

In music, the key of a piece provides an underlying unity — generally, any note out of key will sound discordant. In fact, certain keys have distinctive sound qualities by which they can be recognized. Major keys, for example, are lighter and happier, whereas minor keys lend themselves to sadness and melancholy.

Similarly, in painting, the light key unifies the painting. Everything seen under one light stands together as a harmonious whole. A collection of differently colored objects, such as two apples and a French horn on a blue table, viewed under the same light would still have a certain unity by virtue of the common illumination.

Just as musical keys are identifiable, light keys are, too. The most obvious distinction is between a sunny day and a cloudy day, but an almost infinite variety of light keys exist. The soft, hazy light of a summer twilight by the ocean is easily distinguished from the sharp clarity of a clear winter morning on a mountaintop. Even the same kind of day, such as a sunny spring afternoon, will have a different quality of light in the tropics than, for example, in the Arctic. Many influences combine to create the light key — the overall atmospheric lighting condition that affects all that the painter sees.

You can think of the light key as the color and quality of the pervading light. We may have a rosy light key at sunset and a blue-violet light key on a cloudy afternoon. To capture this effect, don't cast every color in the painting with the color of the light key, as if seen through a colored lens. The light key affects the color relationships in specific ways, discernable only through observation. Through full-color seeing, we can learn to be sensitive to the overall light key as well as to its effects on all the color relationships in a painting.

Palm Tree and Roof Top Light Key Demonstration, 20″ × 24″

Of the quick studies below, the first six were painted on a bright summer day in California, starting with sunrise (1), and moving left to right through early morning (2), late morning (3), early afternoon (4), late afternoon (5) and sunset (6). I returned on a stormy morning (7) and again on a hazy morning (8). See how each of the major masses changes in color from painting to painting — the sky, palm tree, tree on left, chimney and rooftop. Simple subjects, as in this study, with a few clearly defined masses are best for learning light key. It's easier to study the effects of the changing light when you don't have to paint a lot of complex forms.

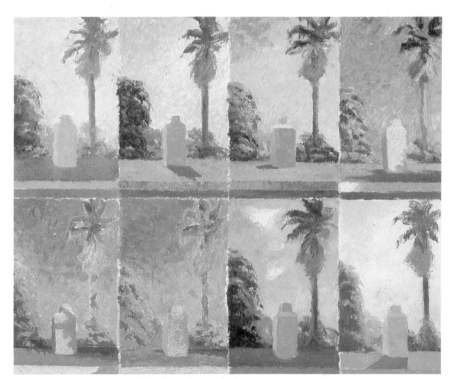

Painting the Light Key

This is an early-morning summer scene of the American River. I painted it from 7:15 A.M. to 8:15 A.M. and returned about twenty times on mornings when the weather was the same. I do this to capture the effects of light at a specific time, place, weather condition and season. I liked the soft light on the river—a good scene to show light key.

The light key is the overall atmospheric effect of light that surrounds everything at a given time and place. For example, a cloudy day has a different light key than a sunny day or a foggy day. To understand this morning light key, I recalled other light keys and made comparisons between them.

The subject of this painting shows how the light key of this early sunny morning affects the color masses. The simple masses in this landscape show how the soft, warm light touches all the colors. The pervading light is yellow-gold, but this does not mean all the colors are tinged with yellow. Some of the masses are quite cool, but they still appear to be in the same light. Just as with musical notes in a musical key, a color note that is out of key will seem out of place or discordant.

This is a photograph I took standing on a bluff looking down at the river. I painted this scene on early summer mornings for about twenty days. The light changes very quickly at this time of day, so I could work only about an hour at a time. I liked the distance, atmosphere and relative simplicity of the masses.

STEP 1. As I made my initial color statements of the major masses, I indicated the light key of the early morning light. Notice the pale yellow of the sky and the pinks, yellows and purples in the water. Early morning often has a soft light, with little contrast. In this stage the water is seen as flat color masses; the ripples are details, which will be painted later.

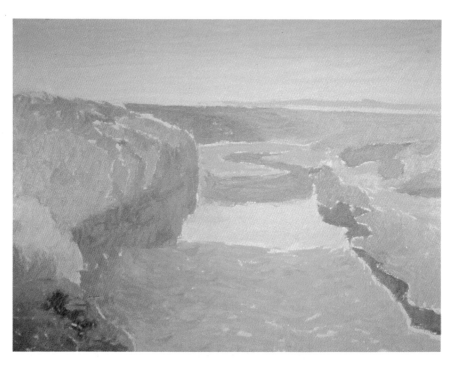

STEP 2. I began to refine the major color notes and see some beginning color variations, all within the same light key. The water in the foreground is warmer and more orange on the right, and it has more blue and purple on the left. Each color was refined by comparison to other color notes while also keeping in mind the light key of early morning.

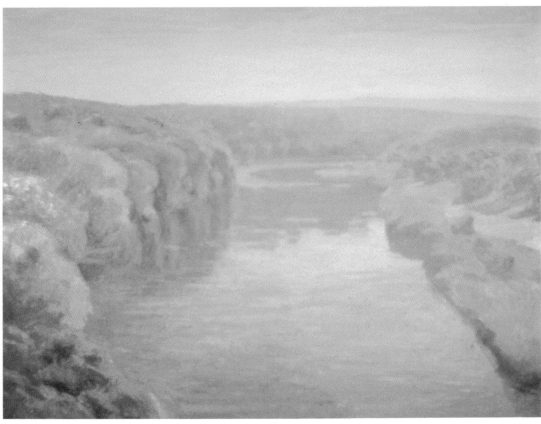

STEP 3. As I developed more variations, the trees on the left took form. Seeing and painting color variations in the water caused ripples to appear and the reflection of trees on the left to become more obvious. I also began to see indications of trees on the far distant banks. Notice that these have less contrast and less definition; also, they are slightly cooler in color than the near trees.

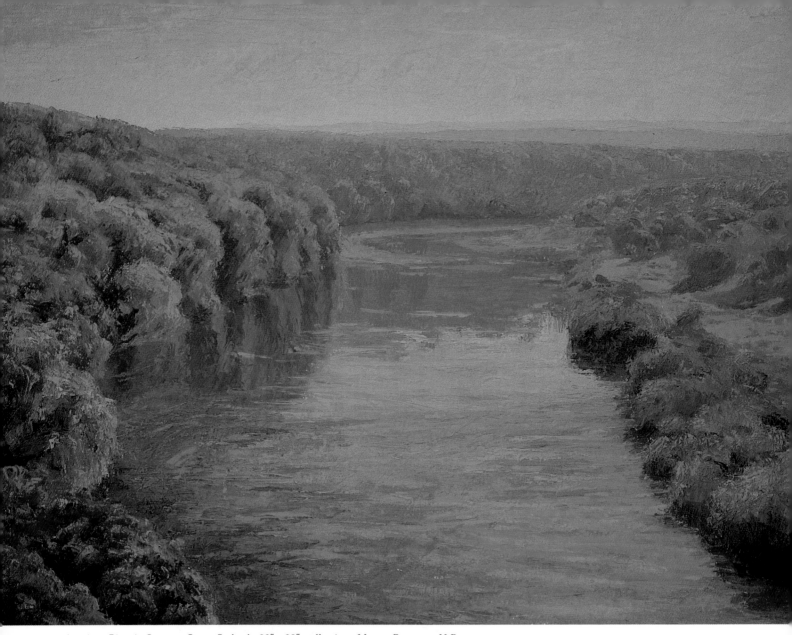

American River in Summer, Susan Sarback, 22″×28″, collection of James Bonnette, M.D.
This shows increasingly smaller variations on the trees on the left. The trees are noted as light and shadow, warm and cool, without describing each leaf and branch in detail. Notice the range of shadow colors in the trees; they're not all the same. Scanning, as in still life and block studies, is the way to see these differences in color.

By making more variations in the foreground water, the ripple pattern from the wind is apparent. Farther back the river is calmer, with areas of light orange, pink and yellow reflecting from the warm sky. In the distance, the river is a warm violet reflecting a bank of trees. The sky was mostly yellow, but I saw other warm colors and the beginning of coolness at the top. I actually used a blue-green in the sky.

DETAIL. Notice the variety of color in the river in the foreground. Even though it's a soft, warm morning light, the full spectrum of color is present — from warm violets and cool violets, to yellow, blue-green, blue and a warm, rose color. Yet from a distance this section holds together and reads as one mass.

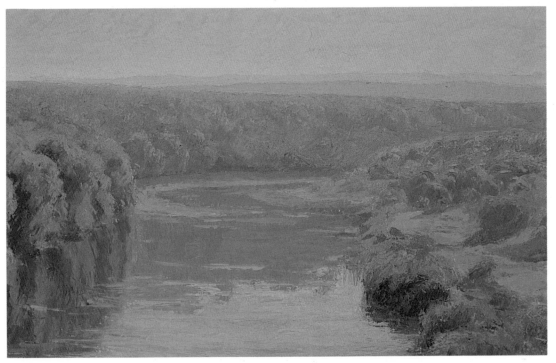

DETAIL. This section has close color harmonies, but again the full spectrum is still present. Notice that the forms in this background section are indicated with patches of color rather than described literally. The colors are not based on theory; they have to be scanned and compared to be seen accurately.

Comparing Light Keys

This is a series of quick light-key studies of the same subject painted at different times of day and under varying weather conditions. They show clearly how the light key affects the colors of a subject. This scene has only six major masses, making it relatively simple in composition and a good choice for a light-key study.

I worked on each study for about an hour. As I painted each one, I had to observe, scan and compare, as well as remember what the other keys looked like. For example, when I painted in the late afternoon, I had to keep in mind the light effects of other times of day. In this case, I actually took my late morning study with me, to make sure I clearly saw the difference between these two times of day.

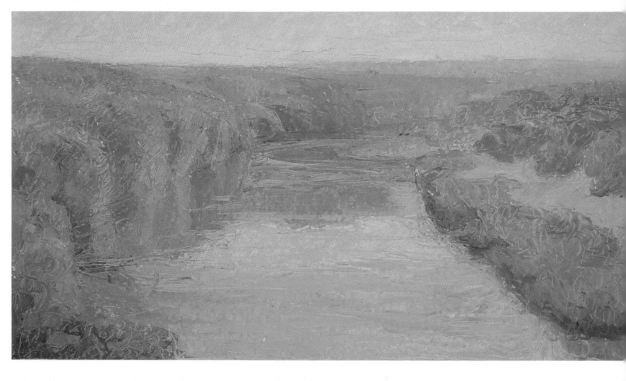

American River, Hazy Summer Morning
Susan Sarback,
10″×16″
(7:00 A.M. - 8:00 A.M.)
This study was painted on a summer morning with dense haze. The high humidity made everything a little milky, so the colors contained a lot of white. This is appropriate for a hazy day but not for a bright, sunny day. If you add too much white on a sunny day, your painting will look washed out.

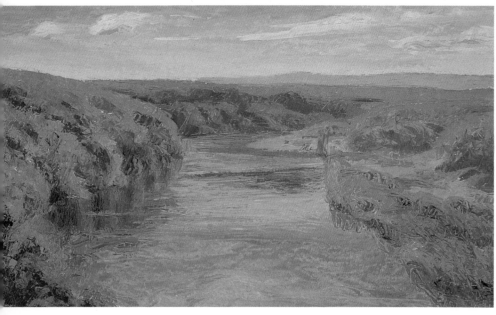

American River, Sunny, Late Morning
Susan Sarback, 10″×16″
(9:30 A.M. - 11:00 A.M.)
As the morning progresses, the colors change. Compared to the earlier morning scenes, the sky is bluer. The right-hand bank has more direct sun and so is warmer. The distant bank is darker and more purple, and the water is bluer and cooler. I changed canvases when I noticed the light had lost the warm glow of early morning and become cooler. If I try to paint after the light key has changed, none of the colors look right. I end up with two different light keys in one painting.

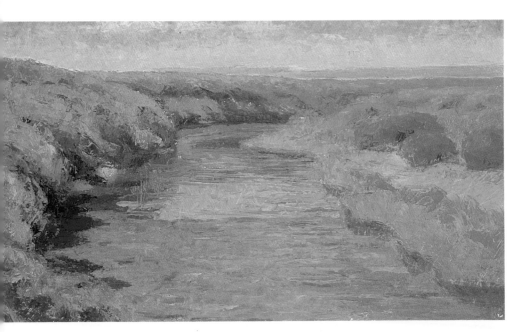

American River, Sunny Afternoon
Susan Sarback, 10″ × 16″ (3:30 P.M. - 5:00 P.M.)
In this scene, the colors in the afternoon were generally more intense than in the morning. The sky is a deeper blue, the bank is orange, the foliage is warm orange-greens, and the water has richer, more intense colors. The foreground water is very orange on the right, and green and blue on the left. The light planes are warmer than in the morning, and there is greater distinction between light and shadow. I compared this scene to my morning versions to help me see it better.

American River, Sunset
Susan Sarback, 10″ × 16″ (7:00 P.M. - 7:45 P.M.)
The glow of the sinking sun called for intense, hot colors, practically straight out of the tube. The light at sunset has an even greater contrast between bright and deep than in the afternoon, and it is usually very warm. The water is a very warm orange-yellow, reflecting the warmth in the sky. The distant hills in the background show how full-color seeing does not always lead to the same colors as theories. According to the formula that cool colors recede, the distant hills should be a cool color, but because of the warm, intense light, they are actually quite warm.

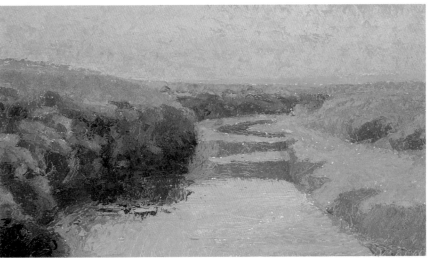

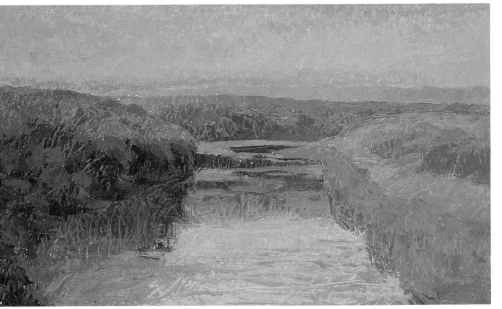

American River, Dusk
Susan Sarback, 10″ × 16″ (8:00 P.M. - 8:30 P.M.)
This painting was done very quickly to catch the last traces of the sun just as it set. The light had a warm, red-violet glow, like the end of a fire. The bright orange note shows the distant right bank as it catches the final rays of direct sunlight. This painting differs from the sunset painting in that colors are cooler and not as bright.

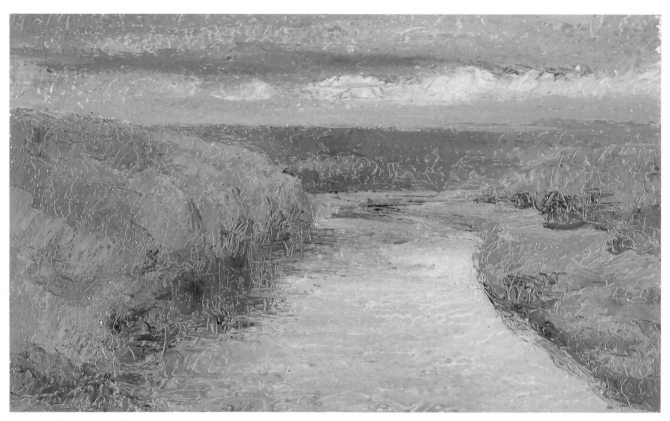

American River, Stormy Morning

Susan Sarback, 10″ × 16″ (9:00 A.M. - 11:00 A.M.)

An unusual stormy morning in summer sent me racing to the river for this quick study. I painted under a tree through the intermittent rain. I wanted to catch the deep blue-purple cast of the light. I used the same full palette in this painting as in all the others. Although it may appear that the colors are limited to cool colors, in fact there are traces of pale yellow in the water and orange notes on the right bank.

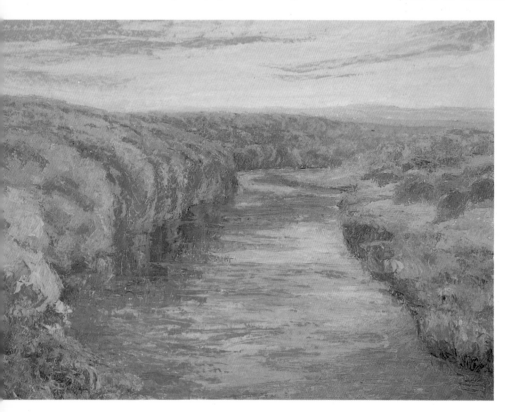

American River, Overcast Morning

Susan Sarback, 16″ × 20″

(8:00 A.M. - 10:00 A.M.)

Except for the orange-yellow cast to the sky, this painting is generally cool. It is cooler than on the sunny days, but not as cool as on the stormy day. The morning was mostly overcast, but sunlight filtering through the clouds on the right bank and the trees on the left gave it more warmth than it had projected on the stormy day. Notice how the foreground water moves from blue-purple on the left to purple-ochre on the right.

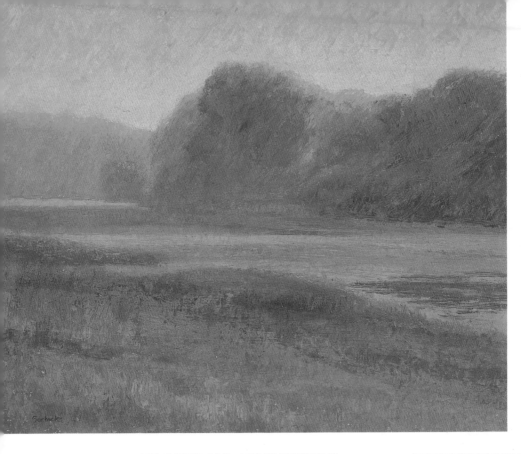

River Dawn, Susan Sarback, 20″ × 24″
collection of Peter Senter
This painting was done at 6:30 A.M. on summer
mornings for about two weeks. At first, I painted
the distant hills a magenta color. As I continued
painting, I saw that they were drenched in
golden light, so I added some yellows and
oranges. But the overall atmosphere did not
make everything golden yellow—the blue
shadow in foreground was light and cool.

AN OVERALL ATMOSPHERE

For several years while studying, I heard about the light
key, but I understood little about it and never saw it. Then
one summer, while painting a sunrise over hills and a river,
I realized that to get the color of a distant hill correct, I
had to drench it in yellow-gold light. I saw that the whole
scene was affected by an overall atmospheric condition. I
had to exaggerate the effect of the yellow-gold light on the
hill to get the color right in relation to the surrounding
colors. I had discovered the effect of the light key.

Painting in this light key did not mean that I had to add
yellow-gold to all the colors. Instead, I saw how the blue
shadow in the foreground had to be pushed lighter and
cooler than I had initially seen it, so that it would appear
in the correct light key. Not only did I relate the foreground
to the distant hill (parts to parts), but I also had to relate
both the foreground and the hill to the overall lighting con-
dition (parts to whole). I also did a painting of the same
scene at a different time of day, later in the morning, which
helped me see the dawn light.

For the first time, after many years of painting the color
relationships, I could see how the light key affected them.
And by displaying correctly both the color relationships
and the light key, that painting radiated a subtle unity that
moved noticeably beyond my former paintings.

Autumn Fog, Susan Sarback, 24″ × 18″
This painting was done on a cold, windy morning in October. Full-color
seeing helped me to see specific colors instead of just shades of gray,
even in the fog. The colors were subtle but still present. Notice there are
blues, violets, oranges, reds and yellows on this seemingly gray day.

SEEING THE WHOLE

Understanding the light key is seeing the whole. It is the overall lighting condition that we see, and it permeates all of the colors, unifying them in a subtle yet perceivable way. If a color note pops out of a painting, often it's because it's not in the light key, just like a discordant note in music sounds out of place. The light key transcends the details of a painting and grants it a harmony and radiance that arise only out of the whole painting.

The all-pervasive quality of light at a given place and time lends unity to any scene, but also makes for difficult perception. Immersed in a given light effect, we tend to overlook it. But if this overall light effect tends to slip from awareness, how can we begin to see it?

We learn to perceive the light key by comparison. For example, where I live in California, the weather is bright and clear much of the year. Painting over a long string of sunny days, I tend to forget, or overlook, the full warmth, intensity and high contrast of direct sunlight. The dramatic difference of a rainy or cloudy day helps me remember how fresh and bright a sunny day really is. To see the character of a particular light key, the painter must experience other light keys as a frame of reference.

This kind of perception is analogous to the knowledge a portrait painter gains with experience. The artist who has painted hundreds of portraits will have greater insight into the specific character of a particular head than the student beginning her first portrait. The portrait artist compares each subject to all of the others she has painted. She may notice that a subject has unusually deep-set eyes, particularly full lips, and smaller-than-average ears. Prior experience creates a context that enables her to see the exact nature of each individual more clearly.

Similarly, by painting in different kinds of light, we can understand a variety of light keys. By comparing light keys and remembering the differences, we create a context from which to perceive the individual nature of each.

As we study the effects of light, we need to know how a scene looks under different light keys. We may rely on memory or on other studies and paintings to compare one time of day to another. When painting a noon scene, for example, we may compare it to our memory of that scene at dawn, and in the evening. Later, as we become more sensitive, we may also compare it to the late morning, mid-afternoon and late afternoon.

Henry Hensche once told me, "If you only paint in one light key, you will get into a mannerism. Experience as many light keys as possible."

We can't truly know one light key until we know many others, for it is the comparisons among them that show us the uniqueness of each one.

Bridgehaven Sun, Frank Gannon, 20″ × 26″
The light planes of this sunny California coast scene are warm and golden; the shadow planes are purples and blues. These color relationships help create a sense of a sunny day. Notice how the colors are brighter and more intense in the foreground and more subdued in the distance. The water in sunlight is blue but has a lot of warmth in it, and the sky is even warmer.

Bridgehaven Fog, Frank Gannon, 20″ × 26″

In this painting, the colors are deeper, less intense and more somber. The water is a subdued combination of both cool and warm colors. The far bank, shrouded in fog, compared to the deep shadows of the foreground, lend this painting a sense of drama. These two paintings appear totally different, yet both portray the exact same scene — the only difference is the light condition.

LEARNING TO PAINT THE LIGHT KEY

The best way to begin perceiving the light key is to study how it changes throughout the day — from mornings to afternoon and early evenings — and how it alters with the weather and seasons. Begin with the most basic distinction — comparing a sunny day to a cloudy one. Observe the difference in the quality of light on days that are alternately cloudy and sunny, or when a cloudy day falls next to a few sunny ones. Paint the same scene on both a sunny day and a cloudy day. After becoming familiar with the difference between sunny and cloudy, tackle the differences that occur between periods of time, such as morning and afternoon. The overall quality of the light affects every color relationship, uniting all that is observed into a distinctive whole.

Just as in our initial study of color relationships, the study of light keys proceeds from the obvious to the subtle. Our beginning ability to distinguish sunny days from cloudy days expands to delineate more specific effects: hazy sunny morning, clear sunny afternoon, foggy days,

rainy days and so on. As we gain experience, the subtleties of these distinctions become more and more apparent.

Doing small studies of the same scene at different times of day is a good way to experiment with light keys. Small studies don't permit an emphasis on details. They provide good practice for capturing the light effect in a few main color notes. Bold statements are useful for beginning painters; exaggerating the differences between morning and noon or afternoon and early evening helps make the difference easier to see.

LIGHT KEYS CHANGE OVER TIME

The light key does not remain constant; it changes over time. After a certain period, it changes so much that work cannot continue on the same painting. There are several time periods to account for—the changes throughout a given day, the changes from day to day, and the changes from season to season. These will vary for different regions of the world.

In California, where I live, a sunny day contains about seven major light keys: sunrise, morning, late morning, midday, afternoon, late afternoon and sunset. These periods will be more subtle on a cloudy day. The amount of time the light stays relatively constant is shorter toward the beginning and the end of the day and longer in the middle. For example, painters have only about thirty minutes to paint near sunrise and sunset, whereas midday is spread out over about one and one-half hours. A painting is developed by working at the same time of day on a number of days with similar conditions.

Throughout the year, the light key changes with the seasons. The seasonal light keys depend on where you live. For example, the shift from summer to fall is quite dramatic in Vermont and much more subtle in Hawaii. Some painters work on paintings from one year to the next, as similar seasonal conditions recur.

Fine Rock Sunrise, Frank Gannon, 16″ × 20″
This is a sunrise painting done along the northern California coast. Compare this painting to the afternoon light in the following painting. Notice that the shadow colors are not as cool and not as deep. The morning sky is warmer and lighter. Generally, there is less contrast between light and shadow in the early morning.

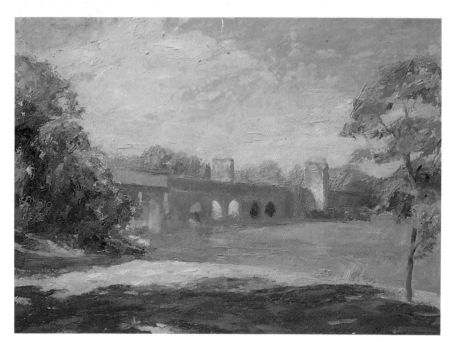

The Old River Bridge
John Ebersberger, 12″ × 16″
collection of Sue and Harold Powell
In this painting, the sky is cooler and richer than sunrise. This painting was done on the East Coast, where the air has more moisture than the West Coast. Even though the sunrise scene was by the ocean, it still contained a crisper, sharper light than the East Coast. Regional differences become more obvious as you become more sensitive to different qualities of light.

COMPARING LIGHT KEYS

It may help to describe in some detail two of the more obvious pairings: sunny vs. cloudy and sunrise vs. midday. Sunny vs. cloudy is the easiest distinction to make, and sunrise vs. midday is one of the most obvious distinctions within the same day. Keep in mind that these examples are generalizations. They are not formulas. Each of us must finally rely on our own vision.

Sunny Vs. Cloudy

A sunny day has clear distinctions of light and shadow; a cloudy day has less obvious distinctions. An apple in full sun will show a definite difference between the sunlit side and the shadow side, whereas on a cloudy day, the light will fade softly into shadow. Colors in sunlight tend to be warmer than those under clouds. The sunlit side of the apple will be warmer on a sunny day than on a cloudy one. This is not to say that warm colors are not present on a cloudy day. They certainly are, but a cloudy day causes the light key itself to be cooler.

On a sunny day, the light key of a particular landscape may be a warm color; however, on a cloudy day, the same landscape's light key may be a cooler color. Both days will have warm and cool colors, but the overall light effect will be different.

Sunny-Day Sunrise Vs. Afternoon

Dawn is easily distinguished from afternoon. As the sun rises in the sky, it loses its fiery glow, usually becoming paler in color and shedding a more brilliant light. Generally speaking, the light key of sunrise is warmer than that of afternoon, though both are on the warm side of the spectrum.

The light keys change more subtly between sunrise and afternoon than between sunny and cloudy days, but this change is more obvious than many of the other light-key differences (i.e., late morning to early afternoon, rainy day and cloudy day, rainy summer day and rainy autumn day). With patience and experience, more and more of these distinctions become evident.

Cape Cod Wildflowers, Sunny Day
John Ebersberger, 24″ × 27″, collection of Robert Mand
Notice the bold, clear colors in this sunny-day painting. Don't be afraid to use colors straight out of the tube to capture the brilliance of full sun. Notice the warmth in the shadow areas — orange-reds in the background bushes and red-violet on the path.

Cape Cod Wildflowers, Cloudy Day, John Ebersberger, 12″ × 16″
On cloudy days, and foggy days, the sky can seem to be a nondescript neutral color. But if we compare the sky in the foggy painting to the sky in the cloudy painting, we can see that the artist actually saw specific colors in the sky; the cloudy-day sky is a warm violet, and the foggy-day sky is more yellowish green. Studying different light keys makes it easier to see each one. Compared to the sunny day, the cloudy colors are muted, but when we compare to the foggy day, we see they are also quite rich.

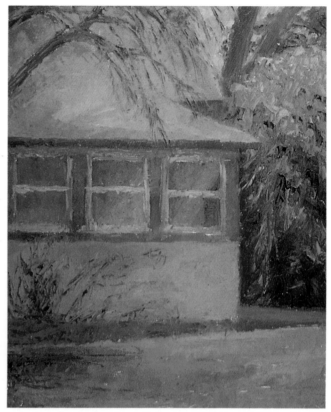

Sunny Day Cottage, Susan Sarback, 14″ × 11″

These quick studies show the contrast between a sunny day and a cloudy day. In this painting, I first established the light-and-shadow planes as simply as I could. I painted a single, cool blue-violet note for the roof and side of the house in shadow. Notice that shadow colors on a sunny day are not the same as cloudy-day colors. The sunny-day shadow note on the house is a warm violet — a very different color from that of the cloudy-day house. The grass in shadow on this sunny day was a deep blue-green, but it was a muted green color on the cloudy day.

Cloudy Day Cottage, Susan Sarback, 14″ × 11″

This study shows the same subject, but with a different weather condition and a different season. The colors are muted but were not mixed by adding black. Black makes my colors dull. I like to mix colors to achieve the subtle, complex colors. For example, the side of the house is a muted blue, whereas the rooftop is a mixture of pale greens and purples.

Natural Light Vs. Artificial Light

The light key of a painting will be influenced by the source of light. Natural sunlight has qualities that aren't duplicated by artificial light, such as a balance of the full spectrum of colors. For this reason, most students study color outdoors, although this may not be convenient for everyone, especially in bad weather. Next best is painting by a window with natural light as the only source of light.

If you do paint indoors under artificial light, it is helpful to know the particular qualities of your light source. Four common types of artificial lighting are incandescent, fluorescent, full-spectrum and halogen.

Incandescent lighting tends to shift colors to the warm side, while fluorescent lighting generally makes colors appear cooler. In addition, the range of color is reduced with these types of lighting, obliterating some of the more subtle color variations.

Full-spectrum light offers a wider range of color than incandescent or fluorescent. Full-spectrum light comes in varying forms, some of which shift the spectrum in the warmer direction, and others that shift to the cooler side.

I prefer halogen lighting for painting indoors. I believe it contains the widest range of color, and the shift of that range to the cooler side is slight.

Irises by the Window, Susan Sarback, 20″ × 16″

This painting was painted on a cloudy day in spring under natural light from the window. It has
the soft coolness of a cloudy spring morning. Even though it was a cloudy day, I could still see
the full spectrum of color, because I was painting under natural light.

Painting Different Light Keys

This scene, painted in Cape Cod, Massachusetts, is captured here in four different light keys. These are fully developed paintings, showing different times of day, weather conditions and seasons. Compare the overall atmosphere of each one as well as the changes in each specific mass—the distant bank, the trees on the left, the sky and the foreground water.

Foggy Morning at Beech Forest Pond, Stephen Craighead, 20″×24″
Foggy-day scenes generally have close color harmonies, as in this painting. Notice that even the far bank almost completely obscured in mist is still seen as a specific color—a pale, viridian green color.

Cloudy Morning on Beech Forest Pond
Stephen Craighead, 20″×24″
The colors in this cloudy-day version are deeper, richer and more intense than in the foggy-day version. Here the distant bank is rose-violet. The foreground water is deeper pinks, oranges and magenta.

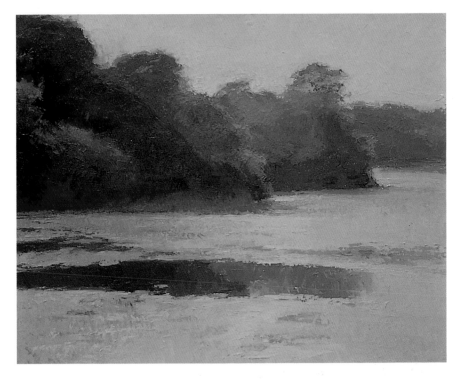

Late Afternoon on the Pond
Stephen Craighead, 20″ × 24″
The overall atmosphere in this painting is much more golden compared to the rosier atmosphere in the cloudy morning. The sky is quite yellow, which is reflected in the foreground water. The distant bank is a cool, deep, blue-purple.

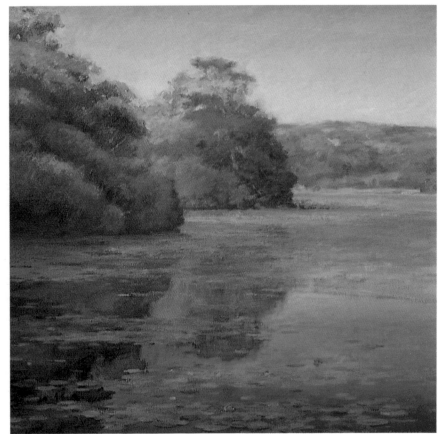

Autumn Morning on the Pond, Stephen Craighead, 24″ × 24″
This painting shows the clear, crisp light of autumn. The sky and the water are cooler and bluer than in any of the other paintings. The distant bank is warm red-ochre, and the near trees show the seasonal change in foliage color, which is reflected in the water.

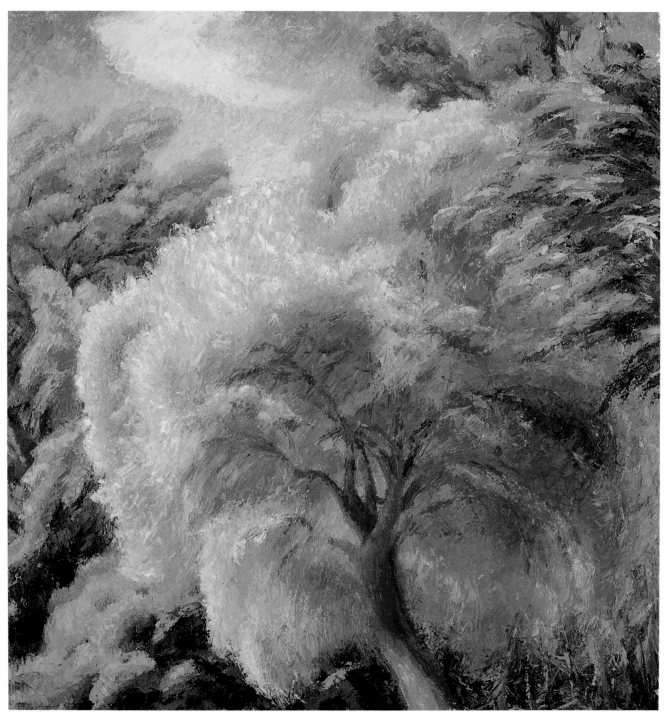

The Olive Tree, Susan Sarback, 24″ × 20″

EXPRESSING YOUR INDIVIDUALITY

If you want to be original—go back to the origin of things.
The best art the world has ever had is but the impress left
by men who have thought less of making great art than of living
fully and completely with all their faculties in the enjoyment of
full play. From these the result is inevitable.
The object is not to make art but to be in the wonderful state
which makes art believable. It is living life.
Those who live their lives will leave the stuff that is really art.

ROBERT HENRI

You can't add a thing by thinking—what you are will come out.

CHARLES HAWTHORNE

In the style of the great Venetian school, the idiosyncrasies of Titian,
Tintoretto, Giorgione and Veronese are distinctively each individual's
so that each canvas or any section of it can be recognized as the
particular artist's work. They are similar only in that they express
a universal concept of ideas. Their individuality crept in unknowingly
as they strove to paint truth.

HENRY HENSCHE

I invent nothing. I rediscover.

AUGUSTE RODIN

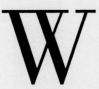

When I studied at the Cape School, I was fascinated to compare the results when several painters painted the same scene. Even when a whole group of advanced painters painted a color study of the exact same still life, it was usually easy to pick out the work of individuals. Many qualities were revealing: composition, thickness or thinness of paint application, size and character of the paint strokes, degree of detail, looseness or carefulness of the rendering, color tendencies and so forth. A painting always carries the stamp of the person who made it.

Inside/Out

Susan Sarback, 20″ × 24″, collection of Gregory Senter, D.D.S.
I'm interested in the process of painting, so I did a series of paintings with exterior borders that show the initial stages of the painting's de-velopment. I left the edges of the painting unfinished and then white-washed the border to create a frame for the interior image. This painting shows an indoor scene opening to the outdoors through a window.

THE LANGUAGE OF FULL-COLOR SEEING

The painter's individuality shines through his or her work in much the same way that each person's handwriting is unique. The artist or writer is focused on the image or the message, yet the results always reflect something of the character and nature of the creator. You can't hide your individuality even if you try—your work always reveals something of who you are.

Full-color seeing is a language of light and color. The receptivity required enables one to become fluent in this language. Just as in speaking a foreign language, until some proficiency is gained, it is difficult to convey one's innermost thoughts and feelings. Once learned, painters can use this language of light and color to express themselves in any painting style, subject matter or medium.

The paintings in this chapter represent a variety of artists who have studied light and color.

White on White, Dezie Lerner, 18″×20″
White objects on a white tablecloth in soft light provide the artist opportunity to study small shifts in color.

Rose's House, Camille Przewodek, 20″×16″
This bold painting of a white house in sunlight clearly shows the artist's enjoyment of loose, free brushwork. The approach is confident, unlabored and direct.

Morning Glories

Margaret E. McWethy, 14″ × 11″, collection of Eileen Atkinson

Clear, clean colors and loose handling of the paint give this painting a feeling of light and freshness. The profusion of morning glories cascading over the fence creates a sense of exuberance.

Tropical Still Life, Stephen Perkins, 18″ × 14″
collection of Dezie Lerner
This painting shows an appreciation of complex patterns of color. Patterns of light and shadow and the decorative patterns on the plate combine to enliven an otherwise simple composition.

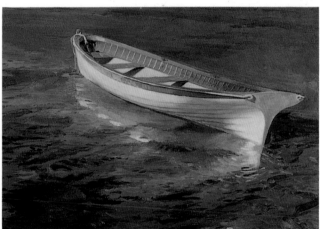

Ebb Tide, Lee A. Boynton, 22″ × 30″
This artist clearly loves his subject and enjoys precise, detailed descriptions of form. His paint strokes are hardly visible and create a smooth, finished look.

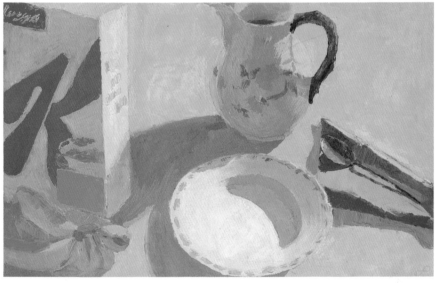

Special K, Dale Axelrod, 16″ × 24″
The objects in this painting are common household items presented in an unusual composition. The paint is applied in an unhurried manner, which gives this painting a relaxed, easy charm.

(Above)
Provincetown Harbor, Hilda Neily, 24″ × 32″
This painting captures the charm of an old New England harbor at sunset.
The color changes are indicated with loose strokes of paint.

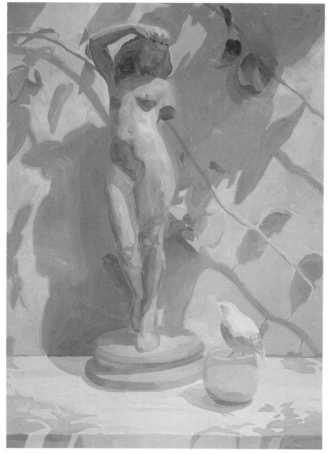

Spring Song, Stephen Perkins, 24″ × 18″
This artist has an interest in sculpture of the
human figure. The classical statue in this
painting is painted with precison and clarity;
many clearly defined color variations are
evident.

The Black Oak
Stephen Craighead, 36″×30″
A bare tree in fog provides the focus for this unusual painting. The rare combination of colors and the refined description of form give a mystical feeling to the tree.

(Below)
Summer Morning, Peter Guest, 23″×30″ collection of Patricia Bennett
This painting captures the mood of a warm, peaceful summer morning. The artist uses light and color to create the feeling of the whole scene. There is no solitary focal point.

Eucalyptus Grove, Chuck Ceraso, 20" × 16"
This artist employs a free and painterly approach. The forms of the trees blend together in a harmony of color that creates the feeling of a sunny day. The interest is not in describing each tree, but rather in the overall effect.

(Below)
Hazy Afternoon, Stephen Perkins, 16" × 22"
The color harmonies in this hazy afternoon painting are very close, yet each form remains distinct.

California Mountains, Ken Massey, 16″ × 20″
This painting shows the artist's appreciation for landscapes with strong, definite forms. The forms in this painting have a solid feeling, and the colors create a sense of earthiness while still being full spectrum.

Afternoon in Loomis, Paula Jones, 18″ × 20″
The colors in this painting are clear and fresh, and the scene has complex forms. The artist was interested in the late-afternoon light as it illuminated the near trees and the distant hills. The forms are noted through color shifts rather than through precise description.

Oranges in the Afternoon
M. Manegold-Wanner, 18″×24″
This artist used color to capture the light effect on the objects in this contemporary still life. She was interested in the patterns created by the striped material and the strong shadows. The forms are precisely seen and painted, and the colors are clear and fresh.

Country Sunset, John Ebersberger, 24″×30″
In this dusk painting, the artist was more interested in using color to capture a light effect than in describing specific forms. The silhouetted trees create a foil for the setting sun.

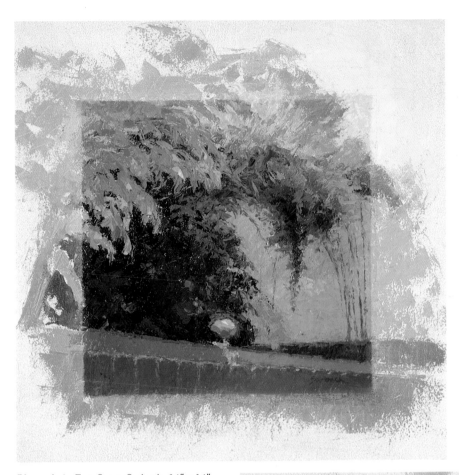

Rhapsody in Sun, Susan Sarback, 14″ × 14″
These two paintings are part of my border
series. Both clearly reveal the painting process.
For this painting, I chose a small section of
nature. My interest was in the movement of
color around the focal point of the rose, not in
describing form in detail.

Rhapsody in Fog, Susan Sarback, 14″ × 14″
In this painting, the same subject as above
is shown on a foggy day. Here, too, I was
interested in the muted colors that surrounded
the rose. The painting is painted loosely and
freely, without tight rendering.

CONCLUSION

apturing radiant color with full-color seeing and painting is a never-ending journey. There is always more to learn and discover. It's an adventure that can keep you inspired for the rest of your life.

This is not an easy approach to painting color. It challenges you to continually stretch beyond your everyday vision to explore a new way of seeing color. For those truly interested in capturing the radiance of light, the results are well worth the effort.

Several years ago, a woman named Alice attended one of my painting workshops. She had no previous painting experience but was determined to learn. Alice spoke very little during most of the workshop until the last day. She was working on a study of a pink plastic cup and a yellow block. As I walked by, she turned to face me, her eyes filled with wonder. "I never knew how in love I could be with a plastic cup," she said. "This isn't just about painting, it's about life."

Full-color seeing and painting has much to offer on many levels, as a language of light and color, and as a way of opening more deeply to life. My hope is that your experiences with it serve you well on your journey as an artist and as a person who loves life.

The School of Light and Color in Fair Oaks, California, with rows of student studies drying in the sun.

Soft Spring, Susan Sarback, 16″ × 12″

INDEX